The Meadows Museum
A Handbook of Spanish Painting and Sculpture

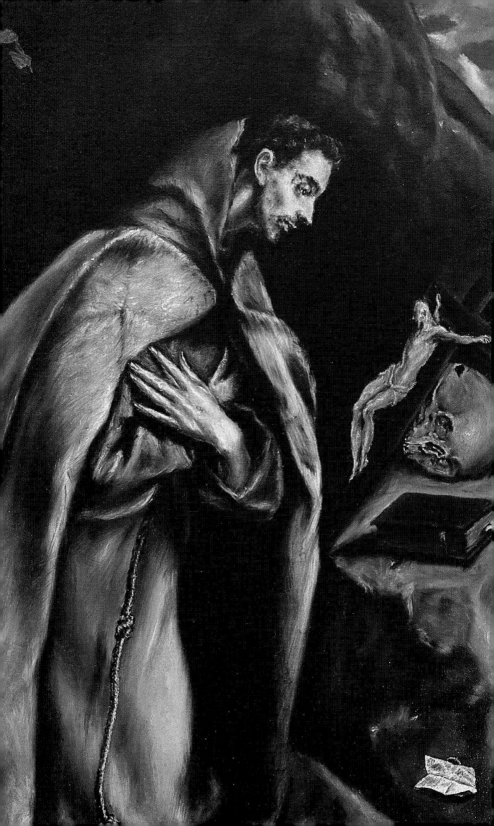

# THE MEADOWS MUSEUM

## A Handbook of
## Spanish Painting and Sculpture

Southern Methodist University
Dallas, Texas
2000

Meadows Museum
Southern Methodist University
Dallas, Texas 75275

ISBN 0-935937-14-5

First edition, 2000.

© 2000 by Meadows Museum.

*Cover:*
ANONYMOUS CATALONIAN, **Eucharistic Cabinet**

*Frontispiece:*
Domenikos Theotokopoulos, called EL GRECO
**Saint Francis Kneeling in Meditation**, detail

*Director's Foreword:*
Juan CARREÑO DE MIRANDA
**Portrait of the Dwarf Michol**, detail

Designed and produced by James A. Ledbetter, Dallas, Texas.

Printed by The Jarvis Press, Dallas, Texas.

*This publication has been underwritten through the generous support of the following:*

Edwin L. Cox

The Samuel H. Kress Foundation

The Meadows Foundation

The Program for Cultural Cooperation Between Spain's Ministry of Culture and United States Universities

Anonymous

# TABLE OF CONTENTS

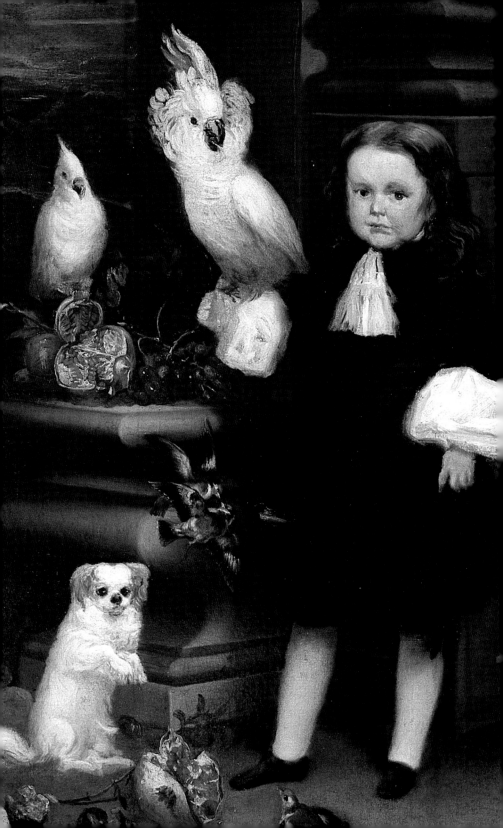

# DIRECTOR'S FOREWORD

It is a special pleasure to write this brief foreword to the Meadows Museum *Handbook*. This is a project which has been "cooking" ever since I became director several years ago; it is now a reality.

Many people and organizations have had a part in our *Handbook*. The donors whose funding was essential are listed on the second title page, but I would like especially to recognize the interest of the Spanish government through its Program for Cultural Cooperation Between Spain's Ministry of Culture and United States Universities.

The individual entries about the art works are at least seventy-five per-cent the work of the museum's curator, Pamela Patton. The remainder were written by myself and Kelly Chamblee when she was Graduate Curatorial Assistant in 1995-96. Ms. Chamblee also prepared the checklists. These entries could not have been done so effectively without important research done by former museum staff members William B. Jordan, Nancy Berry, Irene Martín, Samuel K. Heath, and Marcus Burke. Graduate assistants who contributed research include Caroline Avakoff, Kelly Chamblee, Justine Andrews, Mary Fearon, and Adrien Cuellar. Most of the photographs are the work of Tom Jenkins.

This presentation of the major paintings and sculptures currently in Meadows Museum comes at a particularly exhilarating time for the museum. A new building with six times the space of our current one is under construction and scheduled to open around April 1, 2001. A major grant from The Meadows Foundation made this possible, with further help from significant contributions by other supporters of the museum. I should also like to express my appreciation, and that of Meadows Museum's staff, for the continuing support given our efforts by Carole Brandt, Dean of Meadows School of the Arts, and by William B. Jordan, founding director of Meadows Museum.

Enjoy your journey through the extraordinary and creative artistic energy which has come out of Spain through the past thousand years.

John Lunsford
Director

# THE MEADOWS MUSEUM
## AND THE
### *HANDBOOK OF SPANISH PAINTINGS AND SCULPTURE*

In 1965, the Meadows Museum opened its doors to the public for the first time. The museum's collection of Spanish art and the galleries for its display had been a gift to Southern Methodist University from Algur Hurtle Meadows (1899-1978), a prominent Dallas businessman and founder of the General American Oil Company of Texas. During the 1950s, business took Meadows frequently to Madrid, where repeated visits to the Prado Museum inspired what would become a lasting interest in the art of Spain's Golden Age. By 1962, Meadows had amassed his own private collection of Spanish paintings, which he donated in that year, along with funds for a museum in memory of his late wife Virginia Garrison Stuart Meadows (1901-1961), to Southern Methodist University.

Shortly after the museum opened in 1965, a disheartening blow fell when specialists voiced doubts about some of the works in the collection. With characteristic integrity and the determination that the new museum should contain Spanish art of the finest possible quality, Meadows urged the appointment of a scholar to direct the reshaping of the collection. In 1967 William B. Jordan, a promising American historian of Spanish painting, was hired as the museum's founding director and, in consultation with the Spanish specialists José López-Rey and Diego Angulo Iñiguez, set about the task of removing and replacing the questioned works. Jordan's reconstruction of the collection, with the support of Algur Meadows, would become a collaboration of historic significance: between 1967 and 1978, the year of Algur Meadows's death in a car accident, the two assembled a collection of Spanish masterpieces which today stands among the finest outside of Spain, and has earned the Meadows Museum the affectionate nickname of "The Prado on the Prairie."

Since 1978, the museum's efforts to develop and care for the Meadows Collection have continued with the support of The Meadows Foundation, a general-purpose philanthropic institution created and incorporated by Algur Meadows in 1948. This fruitful partnership has resulted in a comprehensive campaign of conservation, the support of scholarly research on the collection, and a number of important acquisitions, particularly in the areas of medieval, Baroque, and twentieth-century art.

At this writing, the Meadows Collection of Spanish art comprises more than 125 paintings and sculptures and approximately 450 works on paper, which together span the millennium from the tenth century to the end of the twentieth century. These holdings include important medieval objects from Islamic and Christian Spain; Renaissance and Baroque polychrome sculptures; and major paintings by such Golden Age and modern masters as El Greco, Velázquez, Muril-

lo, Ribera, Goya, and Picasso. Because of the number of objects involved, this *Handbook* has been restricted to works of painting and sculpture exclusively. The seventy-nine works of art represented by the illustrated text entries are organized chronologically, while the museum's entire holdings of painting and sculpture are included in the two alphabetically organized checklists at the end of the book. It is hoped that the museum's extensive holdings of Spanish and Latin American works on paper, as well as the twentieth-century European and American works in the Elizabeth Boggs Meadows Sculpture Garden, eventually also will receive the publications that they merit.

The preparation of this *Handbook* was motivated by the tireless curiosity and imagination of the students, docents, teachers, professors, and other members of the public whose presence continues to enliven and illuminate our galleries. It is to them that our work is dedicated.

Pamela A. Patton
Curator of Spanish Art
Assistant Professor of Art History
February 2000

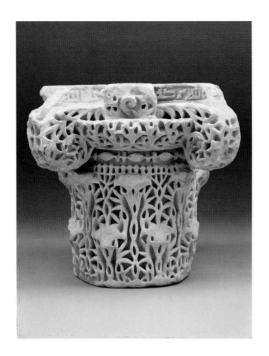

ANONYMOUS HISPANO-
ISLAMIC SCULPTOR
**Capital from Madinat
al-Zahra'**, ca. 965
*Capitel de Madinat al-Zahra'*
marble
Museum Purchase, Meadows
Foundation Funds  96.01

The most powerful rulers of Islamic Spain were the Umayyads of Córdoba, whose brilliant culture reached its height in the middle of the tenth century. This carved marble capital, now removed from its original column shaft, bears a strong resemblance to those produced for one of the Spanish Umayyads' greatest monuments, the vast royal palace complex of Madinat al-Zahra'. Scholars have compared this work particularly with carved capitals from the so-called *Salón Rico*, an important reception room in the now-ruined complex.

The Meadows capital exemplifies the classic Umayyad type, in which Corinthian elements of drum, volutes, and flaring echinus are enveloped by profuse and delicate vegetal ornament. The top and bottom still display incised the geometric schemes by which the sculptor determined the proportions of the capital, a characteristic technique. Also characteristic is the band of Kufic (ornamental Arabic) script that appears at the upper edge of the work. This contains words of blessing and a passage from the Qur'an, along with an illegible passage which may have included the artist's name: "In the name of God. Blessing from God. [missing characters]. . . His perfect (?) servant. In the name of the Merciful God. Blessed is He Who, if that were His will, could give thee better things."

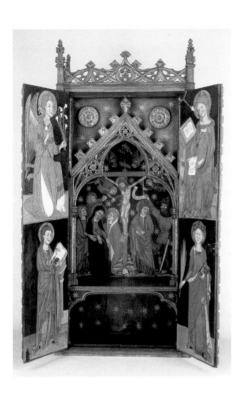

ANONYMOUS
CATALONIAN
**Eucharistic Cabinet**, 1375-1400
*Armario eucarístico*
tempera, gilding, and glazed
silver leaf on poplar wood
Museum Purchase, Meadows
Foundation Funds  91.07

This cabinet is an unusual kind of eucharistic container, or tabernacle, which was used to store the reserve host for use outside the mass.  Monumental cabinets such as this seem to have been common in the Catalan region of Rosselló (now French Roussillon) in the last third of the fourteenth century.  However, very few of these survive: at present, only two similar works exist in museum collections, both of them in Spain.  The cabinet's eucharistic function is reflected in its lively figural paintings, which link the bread and wine of the eucharist with key events of salvation history:  the Annunciation on the doors refers to the transubstantiation of the host during the mass, while the Crucifixion on the rear wall includes such eucharistic symbols as angels who gather Christ's blood into liturgical chalices and a pelican piercing its breast to feed its young.

Although the cabinet has been somewhat altered by restoration, as is common with wooden objects of such antiquity, its most important painted elements remain well preserved.  A notable original feature is the Islamic-inspired *mudéjar* ornament on the outer faces of both doors, a vivid witness to the diversity of Spanish medieval culture.

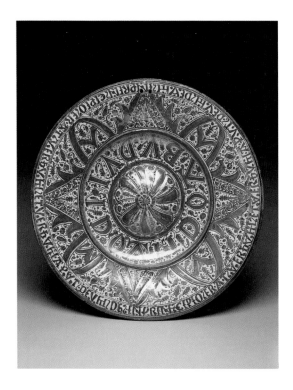

ANONYMOUS
**Hispano-Moresque
Charger,** ca. 1500
*Plato grande hispano-
moresco*
lusterware ceramic
Museum Purchase,
Meadows Foundation
Funds 89.08

The Eastern tradition of making metallic-glazed pottery, or lusterware, was brought to Spain by Muslim artisans before the tenth century. Lusterware technique involves a complex triple-glazing process in which white and colored glazes are enhanced by a metal-based overglaze, resulting in a shimmering, "lustrous" finish. By the late Middle Ages, lusterware ceramics were in such demand that Spanish Muslim, Jewish, and Christian workshops alike had mastered the craft.

This charger was produced around 1500, a period coinciding with the Spanish suppression of Muslim and Jewish subjects by King Ferdinand and Queen Isabella. It is identified as a Christian object by the Latin inscription on its outer edge, which repeats the first lines of John's Gospel ("In the beginning was the Word, and the Word was with God, and the Word was God"). Its intricate foliate designs and slender arches, however, are derived from traditional Islamic ornament. The imperturbable harmony between these culturally disparate elements is an eloquent reminder of the fruitful, if sometimes mercurial, multiculturalism of medieval Spain.

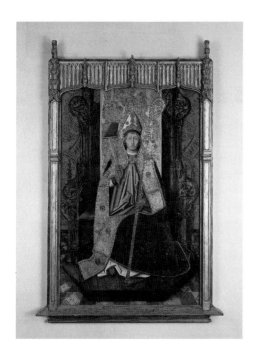

Martín BERNAT
(active 1469-1497)
**Saint Blaise**, ca. 1480
*San Blas*
Oil and gilding on panel
Museum Purchase, Meadows
Foundation Funds 97.01

Saint Blaise, a Cappadocian bishop martyred in the early fourth century, today may be known best as a preventer of sore throats, an association based on his legendary rescue of a child who had swallowed a fishhook. This splendid devotional image depicts the enthroned saint holding a bishop's crozier and a wool-carder's comb, the implement of his martyrdom. Originally the central panel of an altarpiece, the painting would have been surrounded by narrative scenes of Blaise's life and surmounted by a scene of Christ on the cross, as was traditional in Aragonese retables of this era. Also highly characteristic of the Aragonese school are the sumptuous colors and variations of texture, created where gilded areas have been punched, incised, and picked out in high relief *(embutido)*.

   The Aragonese painter Martín Bernat, head of a prolific workshop in the city of Zaragoza, is known for collaborating with other artists of his region, including the renowned Spanish master Bartolomé Bermejo. Bernat's close contact with Bermejo seems to have provided the inspiration for this panel, which echoes the composition of the latter artist's famous *Saint Dominic of Silos* (Prado Museum, Madrid), painted for Daroca cathedral. In the late Middle Ages, such artistic emulation was not only common, but widely approved, since it allowed artists and patrons both to acknowledge and to take advantage of a successful composition.

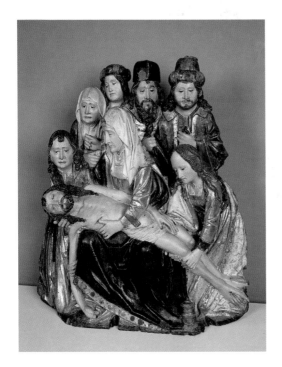

Alejo de VAHÍA
(active ca. 1485-1510)
**Lamentation**, 1490-1510
*Lamentación*
polychromed and
gilded wood
Museum Purchase,
Meadows Acquisition
Fund 89.02

This compelling polychrome sculpture evokes with intensity and pathos one of the most moving events of the Christian story: the lamentation of Christ's followers over his crucified body. Huddled in a semicircle around the broad, stable triangle formed by the Virgin Mary's robes, the figures focus every fiber of their consciousness upon the wounded corpus lying stiffly across his mother's lap.

Alejo de Vahía, active in northern Castile between 1485 and 1510, worked in a late Gothic idiom closely related to German traditions and often has been surmised to be of German descent himself. Certainly it was common at this time for Northern artists to ply their trade in Castile, where their presence was encouraged by the international tastes of Queen Isabella and King Ferdinand.

This narrative group once belonged to a larger carved altarpiece, which probably contained several additional narrative scenes from the Passion of Christ. This accounts for the work's tightly clustered composition and slightly tipped perspective, which would have been more easily legible to a viewer standing below the altar.

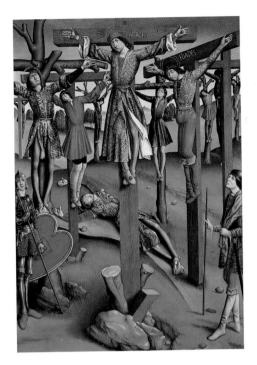

Francisco or Fernando
GALLEGO (1440 - 1507)
**Acacius and the 10,000
Martyrs on Mount Ararat,**
ca. 1490
*Acacio y los 10,000 mártires del
Monte Ararat*
tempera and oil on wood panel
Algur H. Meadows Collection
68.02

This panel must once have formed part of one of the expansive, multipaneled altarpieces typically produced in central and western Spain at the end of the fifteenth century. It honors the Roman centurion Acacius, who, along with his 10,000 troops, was said to have been converted to Christianity while fighting near the Euphrates River. Despite a resounding military victory, Acacius and his company were brought to trial for their new faith, and when they refused to renounce it, all were crucified. A parallelism between this event and that of the Crucifixion of Christ is suggested here by the positions of the three main figures, which recall traditional renderings of Christ on the Cross between the two thieves.

Fernando Gallego, a highly productive and influential late Gothic painter in Spain, was active in Salamanca and its environs during the last third of the fifteenth century. As was true of all of the so-called "Hispano-Flemish" painters, Gallego borrowed the bright, clear palette and precise oil technique of Netherlandish artists, whose works were collected avidly by Spanish patrons of the era.

The authorship of the Gallego school is difficult to unravel: certain discrepancies with signed panels by Fernando Gallego, along with the recent discovery of a second, apparently contemporary artist named Francisco, perhaps a brother or son of Fernando, have led to speculation that the Meadows panel might be the work of this second figure. Regardless of the particular hand involved, the luminous hues, delicate landscape, and harshly modeled faces epitomize the distinctive Gallegan style.

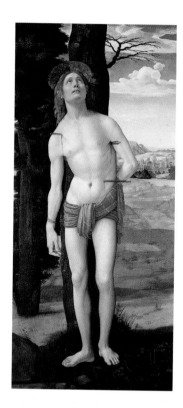

Fernando YÁÑEZ DE LA ALMEDINA
(active ca. 1505 - ca. 1540)
**Saint Sebastian**, ca. 1506
*San Sebastián*
oil on wood panel
Algur H. Meadows Collection 76.02

Fernando Yáñez de la Almedina was one of the first Spanish practitioners of the Italian High Renaissance style in Spain. A native of Valencia, Yáñez is believed by many to be the same "Ferrando Spagnuolo" who is documented working in Florence with Leonardo da Vinci in 1505. That Yáñez had assimilated Italian Renaissance traditions is evident in the idealized anatomy and radiant features of the young saint, as well as in the carefully balanced composition, with its studied atmospheric perspective. In particular, the fine, delicate facial type, crisply delineated foliage, and gentle chiaroscuro effects recall Leonardo's style.

With an attitude of resignation and patient suffering in keeping with his role as a Christian martyr, Sebastian endures the pain of his martyrdom with surprisingly little change of expression. Images of Sebastian, a third-century Christian who miraculously survived an attack of arrows only to be beaten to death by order of the Roman emperor Diocletian, were especially popular during the Renaissance, when the saint was invoked frequently as protection against the plague and other contagious diseases.

Juan de BORGOÑA
(ca. 1470 - ca. 1534)
**The Investiture of Saint Ildefonsus**, 1508-14
*Imposición de la casulla a San Ildefonso*
tempera and oil on wood panel
Algur H. Meadows Collection 69.03

This painting depicts a popular Spanish subject: Saint Ildefonsus receiving a chasuble, or bishop's robe, from the Virgin Mary. Ildefonsus, a seventh-century archbishop of Toledo, was especially venerated in Spain for his devotion to the Virgin Mary and his defense of her immaculacy. According his biographers, Ildefonsus' piety ultimately was rewarded by a miraculous visitation in which the Virgin herself bestowed upon him a golden chasuble.

Juan de Borgoña ("John of Burgundy") was of northern European origin, but he also seems to have studied in Italy. However, he was active primarily in Spain, working in Toledo for the powerful Archbishop Francisco Ximénez de Cisneros. Borgoña's association with this patron may be reflected in the Meadows panel, where the kneeling Ildefonsus bears a strong resemblance to known portraits of Ximénez himself. Borgoña's style blends the rich primary hues of the North with a monumental classicism assimilated during his travels in Italy, bringing to mind the work of painters such as Mantegna and Raphael. Meanwhile, the elaborately patterned gilding that enriches the Virgin's cloth of honor and the archbishop's famous chasuble has an undeniably Spanish quality.

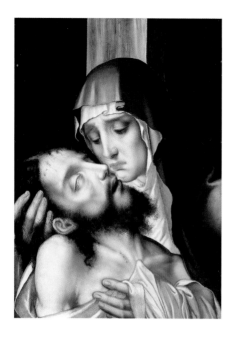

Luis de MORALES (1509?-1586)
**Pietà**, ca. 1560
*Piedad*
oil on panel
Museum Purchase, Meadows
Foundation Funds 95. 01

Luis de Morales was known as *El Divino* ("the divine one") for the idiosyncratic spirituality of his religious images. Based in Estremadura and Portugal, he worked for several prominent ecclesiastical patrons but was especially renowned for small devotional panels such as this one. Drawing upon Flemish and Italian models, Morales developed an individualistic style in which exquisite draftsmanship, polished execution, and sublime emotional expression reflect the fervent mysticism of Counter-Reformation Spain. This painting, among the finest of Morales's numerous versions of the *Pietà,* depicts the Virgin Mary embracing her dead son, the proximity of their profiles intensifying the scene's quiet sorrow. Delicate modeling, a glossy surface, and nearly invisible brushwork give the figures a smooth tactility enhanced by the Virgin's crystalline tears and the fine, calligraphically rendered hair and eye-lashes.

This panel is close in style and composition to Morales's full-length *Pietà* in the Real Academia de San Fernando in Madrid, one of the artist's acknowledged masterpieces. This association places it within the richest and most productive period of Morales's career. The recent discovery, using infrared reflectography, of a fully worked-out underdrawing beneath the paint surface helps to confirm its centrality in the artist's oeuvre and offers insight into his working methods.

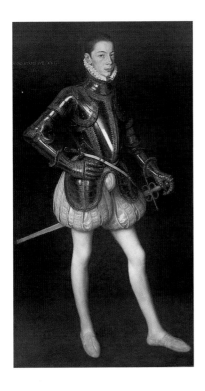

Anthonis MOR (1517-1576)
**Portrait of Alessandro Farnese**, 1561
*Retrato de Alessandro Farnese*
oil on canvas
Algur H. Meadows Collection 71.04

Although the acclaimed Flemish painter Anthonis Mor worked only briefly at the Spanish court, his example would reshape Spanish painting traditions. In 1559, Mor was summoned to the court of King Philip II to become his official portraitist. He remained there only for a brief period, returning to the Netherlands in 1561, but in this time he succeeded in establishing the official formula for Spanish Habsburg portraiture, which would endure for more than half a century in the hands of such artists as Alonso Sánchez Coello, Sofonisba Anguissola, and Juan Pantoja de la Cruz before being superseded finally by Velázquez.

This work exemplifies Mor's portrait formula, which served above all to convey the majesty and social distinction of the sitter. Alessandro Farnese, a grandson of Charles V, resided from 1559 to 1565 at the Spanish court, where this portrait no doubt was painted. Mor clearly took pains to create an imposing likeness for the sixteen-year-old youth, a future general and governor of the Low Countries. To give the young Alessandro a presence beyond his years, he portrayed him in an open, wide-legged stance, his left hand resting assuredly on his sword as he confronts the viewer with disengaged calmness.

Because Mor's style was closely imitated by other painters at court, the attribution of his works has been subject to some discussion, and for a short while this portrait was attributed to Sánchez Coello. More recently, however, scholarly consensus has reassigned the work to Mor, whose hand is evident both in the closely observed physiognomy, softened only slightly by a matte surface and the faint blurring of contours, and in the cold, brilliant light, which isolates the figure against a dark ground while illuminating the rich fabrics and metals of his parade armor with dazzling exactitude.

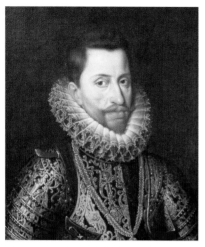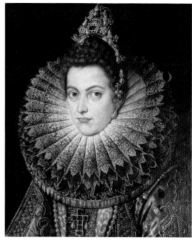

Juan PANTOJA DE LA CRUZ (1553 -1608)
**Portrait of the Archduke Albert**, ca. 1600
*Retrato del Archiduque Alberto*
**Portrait of the Archduchess Infanta Isabella Clara Eugenia**
*Retrato de la Archiduquesa Infanta Isabella Clara Eugenia*
oil on canvas
Algur H. Meadows Collection 65.33 and 65.34

Juan Pantoja de la Cruz served as court painter to both King Philip II and King Philip III of Spain. His predecessor and teacher was Alonso Sánchez Coello, who himself had studied with Anthonis Mor during that Flemish painter's brief time at the Spanish court. Following in the footsteps of these two masters, Pantoja remained faithful to the conventions of formal portraiture that their examples had established.

This pair of portraits depicts the Archduchess Princess Isabella Clara Eugenia, daughter of King Philip II and his third wife, Elizabeth of Valois, and the Archduke Albert of Austria, Isabella's first cousin and spouse. Married in 1599, the couple ruled as Governors of the Low Countries until the death of the Archduke in 1621 left the Archduchess to govern alone. In these likenesses, probably painted shortly after the royal couple's marriage, Pantoja has used richness of costume and formality of pose to define the sitters' status. Elaborate lacework, embroidery, and jewels provide spectacular textural details, while the couple's restrained expressions convey both aloofness and majesty, the very aspects that Spanish royalty preferred to emphasize.

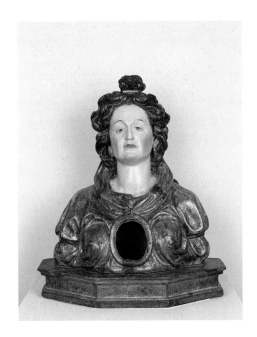

Circle of Juan de JUNÍ
**Saint Ursula**, Second half of the
16th century
*Santa Úrsula*
polychromed and gilded wood
Museum Purchase, Meadows
Acquisition Fund  92.01

According to her legend, Ursula was a fifth-century British princess whose martyr-dom began when she refused an arranged marriage to a neighboring pagan prince. Her resolve won her a three-year deferral of the marriage so that she could travel on pilgrimage, accompanied by eleven thousand other noble virgins. Toward the end of that period, her travels were cut short when she and all her companions were slain by the heathen Huns in the city of Cologne. In the twelfth-century, the discovery in Cologne of a mass burial believed to be that of Ursula and her companions encouraged renewed veneration of the saint, which lasted well into the Renaissance era. Relics excavated from the burial site were often housed in bust-shaped reliquaries such as this one, in which a small opening in the figure's chest allowed the relic to be seen.

The style of this late sixteenth-century bust reflects the classicizing Renaissance manner of the Burgundian-born Spanish sculptor Juan de Juní. Although perhaps not carved by Juní himself, the bust shares the soft, elegant modeling, the Italianate features, and the elaborate polychromy of that artist's autograph works. Particularly expert is the treatment of Ursula's brocaded scarf, achieved by golden *sgraffito* designs incised in multicolored layers of paint.

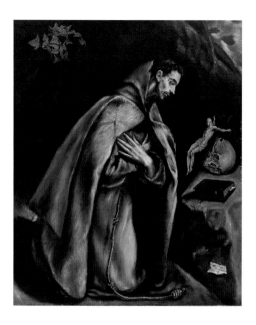

Domenikos Theotokopoulos, called EL GRECO (1541-1614)
**Saint Francis Kneeling in Meditation**, 1605-1610
*San Francisco arrodillando en meditación*
oil on canvas
Museum Purchase, Meadows Acquisition Fund with private donations and University funds, 99.01

The Cretan-born artist Domenikos Thetokopoulos, better known as "El Greco," spent the majority of his life and career in Spain, where he would live from about 1577 until his death in 1614. There, his revolutionary genius was nurtured by the appreciative and unusually refined artistic clientele of sixteenth-century Toledo.

El Greco's innovative spirit is exemplified by this painting of Saint Francis in meditation, a composition which the artist repeated several times late in his life. Unlike conventional narrative renderings of the saint, this devotional work emphasizes Francis's role as a spiritual model. Kneeling before a rocky grotto, he contemplates a crucifix, a skull, and a breviary to demonstrate his detachment from the world, an attitude consistent with contemporaneous Counter-Reformation ideals. Characteristic of El Greco's late work is the graceful elongation of the figure, the elegant handling of the brush, and the brilliant and varied paint surface, which interweaves thin, electric strokes, wet-on-wet passages, and thick, dryish highlights to create a vivid tapestry of form and color. A small sheet of paper, or *cartellino,* at lower right bears faint traces of the artist's signature in cursive Greek: "doménikos theotokópoulos e'poíei."

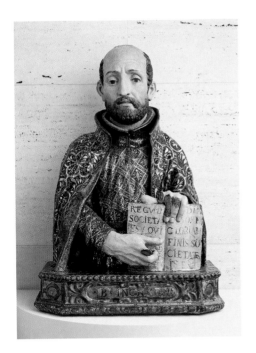

ANONYMOUS
**Saint Ignatius Loyola**,
1609-1622
*San Ignacio de Loyola*
polychromed and gilded wood
Meadows Museum Acquisition
Fund 87.15

Ignatius Loyola (1491-1556) was the founder of the Society of Jesus, also known as the Jesuit Order, which in the sixteenth and seventeenth centuries became one of the foremost missionary orders of the Roman Catholic Church. The saint is depicted here holding a book containing the rules of the Jesuits, which emphasized strict personal discipline, missionary zeal, and an active engagement in the outside world. The inscription on the base of the work adds a striking historical note: it reads "B. Ignatius," or "Beatus [blessed] Ignatius," suggesting that the sculpture was made after Ignatius' beatification in the Catholic Church (1609), but before he was canonized (1622).

Most Renaissance and Baroque wooden sculptures in Spain were polychromed, or painted and gilded, to give the work a lifelike appearance. This sculpture, probably the work of several specialists, represents a pinnacle of achievement in this area. The face and hands are covered in delicate matte tones, while the golden robes glitter with a variety of intricate patterns made by *sgraffito,* in which paint was overlaid on gilding, then scraped away to imitate a richly brocaded fabric.

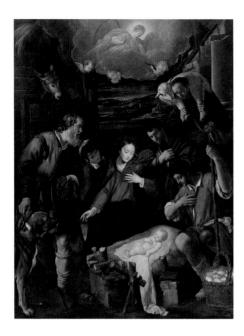

Juan Bautista MAINO
(1581-1649)
**Adoration of the Shepherds**,
1615-20
*Adoración de los Pastores*
oil on canvas
Museum Purchase, Meadows
Museum Acquisition Fund
94.01

The work of Juan Bautista Maino today is best known by specialists, but in his time, this Castilian painter was a central figure at the Spanish court. Half-Milanese in ancestry, Maino traveled in Italy as a young man, where he may have come into contact with such artists as Annibale Carraci and Guido Reni. Returning to Spain in 1608, he settled in Toledo, where, after producing the great altarpiece of Las Pascuas (Prado Museum, Madrid) for the Dominican brotherhood of San Pedro Mártir in 1612-13, he professed as a friar in the same convent. By 1621, however, Maino was called to Madrid to become drawing master to the crown prince, in whose service he would continue after his charge's accession as King Philip IV in 1621. From this point onward, Maino's administrative responsibilities seem to have left him little time to paint, but the few works of his later career, such as the *Capture of Bahía* for the Hall of Realms (Prado Museum, Madrid) reveal an artist of notable subtlety and human sensitivity.

The Meadows *Adoration of the Shepherds* is one of the few major works by Maino to be found outside the Prado. Probably painted in Toledo just before the artist was summoned to Madrid, it reflects Maino's admiration for the early Baroque painters he had encountered during his youthful travels in Italy. His strongest debt is to Caravaggio, as is evident in this work's somewhat theatrical composition, naturalistic peasant figures, and strong contrasts of light and shadow.

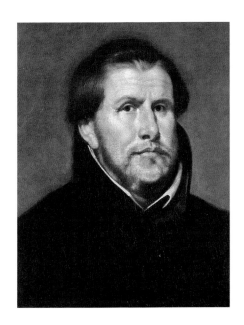

ANONYMOUS CASTILIAN
**Portrait of an Ecclesiastic,**
1620-30
*Retrato de un eclesiástico*
oil on canvas
Algur H. Meadows Collection
71.03

This small but imposing painting descends from a well-established tradition of portraiture which flourished in early seventeenth-century Castile in the hands of such painters as Juan Bautista Maino and Juan van der Hamen. This school, characterized by a dignified restraint, an incisive observation of nature, and carefully controlled brushwork, would be surpassed at mid-century by the more spontaneous and suggestive portraits of Velázquez and his emulators.

Once attributed to van der Hamen, this work has proven difficult to attribute conclusively to an individual Castilian artist. However, its subtle and insightful likeness attests to an artist of the first rank. Following the prevailing formula for Spanish ecclesiastical portraiture, it isolates the sitter against a featureless ground, allowing his bulky black robe and high collar to serve as a foil for robust, congenial features. The jutting jaw, alertly cocked head, and subtly twinkling eye imply a good humor only slightly repressed in response to this formal occasion.

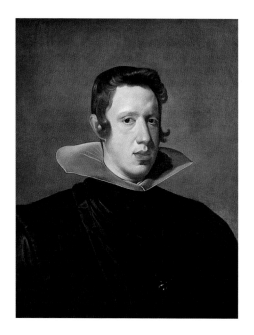

Diego Rodríguez de Silva y VELÁZQUEZ (1599-1660)
**Portrait of King Philip IV,**
1623-24
*Retrato del Rey Felipe IV*
oil on canvas
Algur H. Meadows Collection
67.23

Although a universally gifted artist, Diego de Velázquez may have been at his best as a portraitist. According to his father-in-law and teacher, Francisco Pacheco, it was with a portrait of the young King Philip IV that the Seville-born Velázquez won the royal appointment that launched his career at the Spanish court. Although this bust-format likeness has not been identified conclusively with that initial Philippine portrait, this painting's restrained, incisive handling is characteristic of Velázquez's youthful work, and it displays similarities of style, physiognomy, and format to several other early portraits of Philip IV now in public collections in Madrid (Prado Museum), New York (Metropolitan Museum), and Boston (Museum of Fine Arts, Isabella Stewart Gardner Museum).

Philip IV appears here at the age of eighteen or so, shortly after his accession to the throne in 1621. He wears the sober black doublet and *golilla* (a starched white collar) in which he habitually dressed, a conscious rejection of the elaborate court dress favored by his father, Philip III. The tight, faceted treatment of physiognomy and crisp handling of costume are in keeping with established court portrait traditions which soon would be revolutionized by the young Sevillian artist.

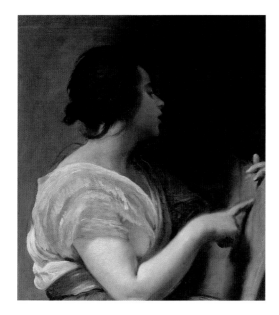

Diego Rodríguez de Silva y
VELÁZQUEZ
(1599-1660)
**Female Figure  (Sibyl with
Tabula Rasa)**, ca. 1648
*Mujer (Sibila con tábula
rasa)*
oil on canvas
Algur H. Meadows
Collection  74.01

This eloquent female figure is among the most enigmatic of Velázquez's canvases.
The work's subject has been disputed, but it very likely represents one of the an-
cient sibyls, prophetesses of Classical mythology who later were believed to have
foretold aspects of Christian history.  One element which complicates our reading
of the work is the simple dress of the figure, which stands in contrast to the more
exotically garbed sibyls popularized by Italian contemporaries of Velázquez, such
as Domenichino and Guido Reni.  Such dress is found, however, in the more clas-
sicized sibyl types of the Italian High Renaissance, including those depicted by
Michelangelo in his frescoes for the Sistine chapel, works with which Velázquez
had become acquainted during his first trip to Rome in 1629-30.  It is possible,
in fact, that the *Sibyl with Tabula Rasa* itself was produced in Italy, perhaps during
the artist's second journey there in 1648-1651, since in 1681, the writer Filippo
Baldinucci reported seeing an "unfinished" painting of a woman by Velázquez in
a private collection in Milan.

Mysterious though it may be, this painting represents Velázquez at the ab-
solute height of his powers.  The brushwork, loose and fluent, imparts a sense of
the effortless and almost accidental; especially translucent passages around the
right shoulder and breast suggest that it may even be unfinished.  Yet the restrained
elegance of the composition, the muted color harmonies, and the evocative poet-
ry of the figure's parted lips and "lost" profile demonstrate an assured mastery
which few artists ever attain.

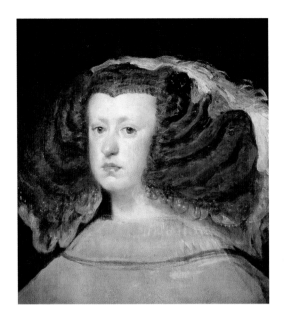

Diego Rodríguez de Silva
y VELÁZQUEZ
(1599-1660)
**Portrait of Queen
Mariana**, ca. 1656
*Retrato de la Reina
Mariana*
oil on canvas
Algur H. Meadows
Collection 78.01

This fresh, evocative image of Mariana of Austria, the young second wife of King Philip IV, offers a rare and informative glimpse into Velázquez's approach to the court portrait. In order to meet the demand for official portraits of the royal family, Velázquez, like other court portraitists, often worked from a studio portrait painted rapidly from life. This in turn became the model for a series of more finished images produced by both the artist and his workshop. This portrait of Queen Mariana, with its lively, bravura handling, sensitively recorded physiognomy, and only lightly sketched costume, very likely was just such a studio portrait, for it seems to have provided the basis for a more fully finished version depicting Mariana in the same wig and headdress and wearing a brown and silver gown. Three versions of this likeness are found today in Barcelona (Thyssen Collection, Monasterio de Pedralbes), Madrid (Real Academia), and Sarasota, Florida (Ringling Museum).

Mariana of Austria was only fourteen years old when she was brought to Madrid in 1649 as Philip's new bride; she ruled as regent from Philip's death in 1665 until 1675, when her son Charles II was declared competent to rule. Her activities as an artistic patron are somewhat overshadowed by those of her husband, but she remained actively involved in the artistic life of the court, sponsoring several of the most promising artists, among them Juan Carreño de Miranda. This portrait, painted at approximately the same date as the more famous likeness in *Las Meninas,* depicts the young queen at the age of about twenty-one. Its light touch and evocative brushwork capture with unparalleled sensitivity the sober, youthful features beneath the heavy wig and rouge.

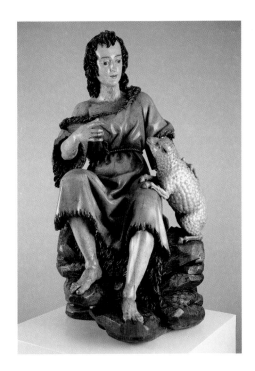

Juan MARTÍNEZ
MONTAÑÉS (1568-1649)
**St. John the Baptist**, 1630-35
*San Juan Bautista*
polychromed wood
Museum Purchase, Meadows
Acquisition Fund 79.01

The long-lived and justly famous Juan Martínez Montañés was the most promi-
nent sculptor of Spain's seventeenth century. Trained in Granada and active main-
ly in Seville, Montañés won countless ecclesiastical commissions with his elegant
and harmonious sculptures, which effectively embody the essence of Spain's Gold-
en Age. This characteristic work depicts the young Saint John the Baptist as a dig-
nified, somewhat idealized youth, who benevolently caresses the symbolic lamb
that leans docilely against his knee.

   This sculpture, which very likely served as the central image of a carved wood-
en retable, is finished entirely in the round so that it could be removed from its set-
ting. This, along with a special support found in the sculpture's hollow base, sug-
gests that the figure was intended to be removed from the altarpiece on special feast
days, when it could be carried in procession.

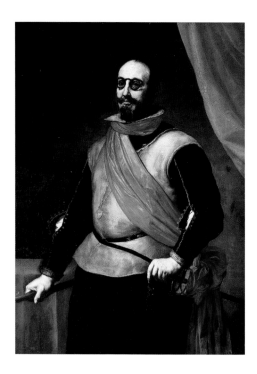

Jusepe de RIBERA
(1591-1652)
**Portrait of a Knight of
Santiago**, 1630-38
*Retrato de un Caballero de
Santiago*
oil on canvas
Algur H. Meadows Collection
77.02

Although his working life was spent in Italy, Jusepe de Ribera continued to emphasize his Spanish heritage, often signing his works "Jusepe de Ribera, *español*." Born in Játiva (Valencia), Ribera had relocated to Italy while still a young man, living briefly in Rome and possibly Parma before settling in Naples by 1616. The effects of Ribera's encounter with Italian painting, particularly that of the north, are clear in this portrait, where a tenebrism reminiscent of Caravaggio's work combines with a sweeping, painterly execution derived from the seventeenth-century Bolognese school. Although the painting almost certainly has been cut down from its original monumental dimensions, it retains a dignity and presence befitting its noble subject.

The identity of Ribera's sitter is uncertain, but he clearly was a person of prominence. The red sash and Captain General's baton identify him as a high-ranking member of the Spanish military, while the shell-shaped medallion, marked with a red cross, signifies his membership in the prestigious Order of Santiago. In spite of the formality of the portrait, he has chosen to retain his large ebony spectacles, which are of a fashionable type sometimes affected by upper-class Spaniards. Besides lending directness to the sitter's already imposing address, the spectacles offered Ribera an opportunity to display his mastery of nature and light: the subtle interplay of shadow and reflection on the cheek and the slight magnification of the eyes by the thick lenses are rendered with an observational ability characteristic of this master realist.

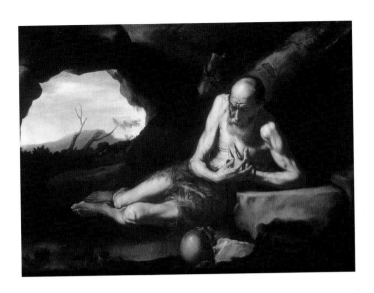

Jusepe de RIBERA and Assistants (1591-1652)
**Saint Paul the Hermit**, 1635-50
*San Pablo Ermitaño*
oil on canvas
Algur H. Meadows Collection 75.01

Of the many works produced by Jusepe de Ribera, perhaps the most influential were his images of penitent saints in meditation, a genre seen at its best in this painting of St. Paul the Hermit. The earthy realism of the saint, with his corrugated forehead, emaciated torso, and grimy and knotted, yet graceful hands, emphasize Paul's devotion to a spiritual ideal while they demonstrate the artist's skillful handling of texture, anatomy, and physiognomy. Ribera's penitent saints were widely imitated by Spanish artists of the latter half of the seventeenth century.

Saint Paul the Hermit is known as one of Christianity's earliest religious recluses. Secluded in a cave, Paul lived a life of strict solitude, self-denial, and religious contemplation. This exemplary behavior no doubt provided a satisfying model for Counter-Reformation viewers, whose own religious practices are referred to by the rosary held by the saint, and who would have been further encouraged by the presence of the skull at the bottom of the canvas, a *memento mori* which warns of the importance of spiritual salvation in the face of death's inevitability.

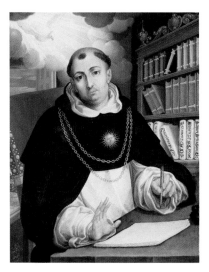 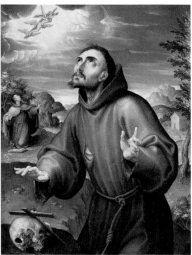

Alonso LÓPEZ DE HERRERA (1580-after 1648)
**Saint Thomas Aquinas** (recto) **and Saint Francis** (verso), 1639
*Santo Tomás de Aquino (recto) y San Francisco (verso)*
oil on copper
Museum Purchase, Meadows Museum Acquisition Fund  88.08 a and b

The practice of painting on metal was relatively common during the seventeenth century in Spain, as well as in its American colonies.  However, works such as this one, in which the copper plate is painted on both sides, are quite rare indeed.  It has been hypothesized that this work, which pairs the theological writer and philosopher Thomas Aquinas with the visionary activist Saint Francis of Assisi, may have served as a door or other element in a liturgical object.  Certainly the selection of these saints, who embody the complementary virtues of the active and contemplative life, suggests an ecclesiastical setting.

Fray Alonso López de Herrera, whose signature appears in the lower right corner of this work's *recto,* was born in Valladolid in north central Spain, but emigrated to Mexico around 1609, when he was still in his twenties.  There, he became a member of the Dominican Order and pursued an active career as a painter.  Like many Spanish-born artists working in Mexico at this time, López tended toward deeply conservative works, in which compositional and coloristic restraint and emotional immediacy often stand in contrast to developments in continental Spain.

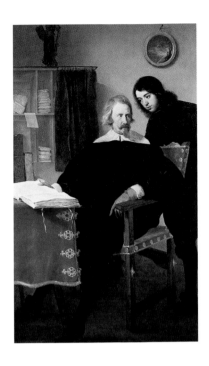

ANONYMOUS
**Portrait of Sir Arthur Hopton**, 1641
*Retrato de Sir Arthur Hopton*
oil on canvas
Algur H. Meadows Collection 74.02

Although much is known about the sitter and date of this very fine portrait, the identity of its artist still remains elusive: in its time, it has been attributed to Bartolomé Murillo, Fray Juan Rizi, Juan Bautista Maino, and Anthony van Dyck. At this writing, however, none of these attributions has been conclusively supported, and the authorship of this painting remains one of the enduring mysteries of the Meadows Collection.

Our knowledge about Sir Arthur Hopton, the subject of the work, is more extensive. He is identified by the coat of arms that appears on the spine of a large book which rests on the desk on front of him, and his facial features are consistent with other known portraits of Hopton. The English noble made repeated visits to Spain, first in 1629-1636 as the secretary to Lord Cottington and again as England's ambassador to the court of Philip IV from 1638 to 1644. Since the date 1641 appears in the painting (inscribed just beneath the coat of arms), it is to be assumed that the portrait was painted during this second trip. An art collector himself, Hopton also was active in acquiring Spanish works of art for King Charles I of England and other British clients.

Dressed in a sober black costume with plain white collar and cuffs, Hopton is captured in a moment of quick reflection before he addresses the young secretary who, garbed in Spanish court dress, attentively awaits his response. Their lively interaction is set off by an array of carefully observed furnishings, from the gold-ornamented chair and large desk to the letters neatly stacked in a cabinet with a blue velvet curtain. The painted roundel hanging on the wall and the small sculpture partially visible on top of the cabinet may make reference to Hopton's activities as a collector.

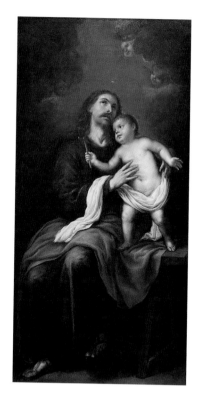

Antonio de PEREDA (ca.1608/11-1678)
**Saint Joseph and the Christ Child,** 1655
*San José y el Niño Jesús*
oil on canvas
Algur H. Meadows Collection 77.05

A slightly younger contemporary of Velázquez, Antonio de Pereda served briefly at the court of Philip IV, participating in the decoration of the Hall of Realms in 1634-35 before finding more permanent success as an ecclesiastical painter in Madrid and its environs. Among the works he produced in this capacity was this painting of St. Joseph and the Christ Child, a signed and dated work which was part of a larger commission for the Chapel of the Children in the Church of the Royal College of Nuestra Señora de Loreto in Madrid. A second canvas from this same project, depicting Saint Anthony of Padua with the Christ Child, is now in the Hispanic Society of America in New York. Both works are notable for their suave, gentle treatment of the saints and their paternal responsiveness to the child Christ.

Pereda's portrayal of the handsome, youthful Joseph reflects larger trends in Spanish painting of the seventeenth century in which depictions of Joseph, the protector saint of the Roman Catholic Church, had increased dramatically as the controversies of the Counter Reformation began to subside. The characteristic medieval and Renaissance depiction of Joseph as an elderly, marginalized figure was concurrently transformed into that of an idealized, attentive young father, the benevolent mentor and protector of the young Christ. This type, which was fully in keeping with Joseph's role both as guardian of the infant Christ and guardian of the Catholic Church, also reflects a new promotion of Joseph as a model for Christian parenting.

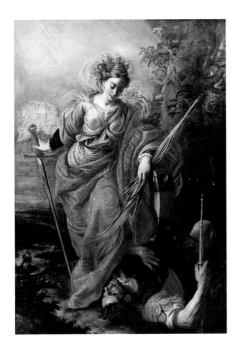

Claudio COELLO (1642-1693)
**Saint Catherine of Alexandria**
**Dominating the Emperor**
**Maxentius,** 1664-65
*Santa Catalina de Alejandría*
*dominando al Emperador Majencio*
oil on canvas
Algur H. Meadows Collection
76.01

Claudio Coello, the son of a Por-
tuguese metalworker, became one
of Castile's leading painters during
the second half of the seventeenth century. Appointed to the Spanish court in
1683, he simultaneously remained active as a painter of ecclesiastical works. Coel-
lo's animated yet monumental style is characterized by a solidity of form which dis-
tinguishes it from the work of other late Baroque painters at the court, such as Juan
Carreño de Miranda. Coello's primacy among Spanish artists was assured by the
production of his now most famous work, *La Sagrada Forma,* for the sacristy of San
Lorenzo del Escorial between 1685 and 1690. Soon after this, however, the artist's
poor health and early death prematurely ended what might have been a brilliant
court career.

Legend describes Saint Catherine of Alexandria as a late third-century virgin
who was renowned for both her beauty and her wisdom. Refusing to renounce
either religion or chastity for the pagan emperor Maxentius, she was put into
prison, whence she argued her case so persuasively that she converted most of the
imperial court. Despite this, Catherine eventually was martyred.

For the seventeenth-century faithful in Spain, still reeling from the contro-
versies of the Protestant Reformation, this story must have served as a particularly
powerful illustration of the Church triumphant, an ideal expressed powerfully here
by Coello's reversion to an emblematic medieval formula showing the emperor
physically vanquished by the young princess. More peculiar to the Baroque is the
careless manner in which the elegant young woman leans against the sword and
wheel of her martyrdom, her draperies swirling about her and her foot lightly rest-
ing on the throat of the bellowing ruler.

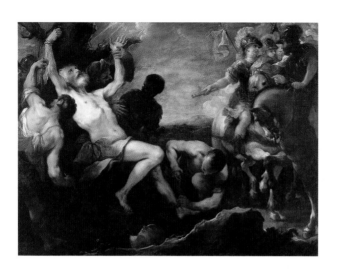

Juan CARREÑO DE MIRANDA (1614-1685)
**The Martyrdom of Saint Bartholomew**, 1666
*El martirio de San Bartolomé*
oil on canvas
Algur H. Meadows Collection 68.01

Juan Carreño de Miranda, court painter to King Charles II, belonged to the last great generation of Baroque artists to work for the Habsburg dynasty. With artists such as Claudio Coello, Juan Rizi, and Juan Martín Cabezalero, his work represents the final crescendo of an artistic tradition soon to be replaced by those favored by the new Bourbon kings. Carreno's *Martyrdom of Saint Bartholomew* exemplifies a type of hagiographical image which had been popularized by the Spanish expatriate artist Jusepe de Ribera. Particularly reminiscent of Ribera's work are the haggard form and complex, foreshortened position of the saint, which echo, if they do not quite match, Ribera's expert naturalism.

According to his legend, the apostle Bartholomew was ordered by Roman authorities to be skinned alive and then beheaded for overturning a pagan idol, seen at the bottom of this composition. Carreño has depicted the martyr tied to a tree, as his persecutors, at the command of the officers on horseback at the right, begin to tear the skin from his arm. Despite this, Bartholomew turns a serene gaze heavenward, displaying his willingness to die for his faith. Characteristically, Carreño's work displays little of the harsh and bloody realism which characterizes much of Ribera's work, but mitigates the scene's more gruesome aspects by means of free, gentle contours, loose brush strokes, and a soft palette of blue, gray, and pink.

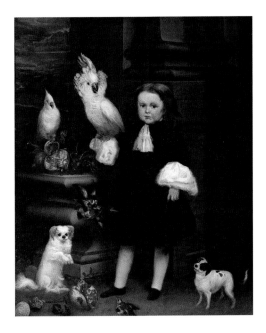

Juan CARREÑO DE
MIRANDA (1614-1685)
**Portrait of the Dwarf
Michol**, 1670-82
*Retrato del enano Michol*
oil on canvas
Museum Purchase,
Meadows Foundation Funds
85.01

Dwarves were a common sight at the Habsburg court in Madrid, where they act-
ed not only as entertainers, but as servants, companions, and nurses to the royal
children. While a tradition of dwarf painting had existed for some time at the
Spanish court, it was revolutionized in the mid-seventeenth century by Diego
Velázquez, whose sensitive portraits of jesters and dwarves strongly influenced the
work of later artists. Among these was Juan Carreño de Miranda, whose *Portrait
of the Dwarf Michol* displays a similarly sympathetic cast. The painting is believed
to be a portrait of a certain Miguel Pol, who traveled to Madrid from Italy during
the 1670s to join the court of Charles II. His depiction with an array of small an-
imals, including cockatoos, goldfinches, and lapdogs, suggests that he may have
been the caretaker of such animals at the court. The opened pomegranate, often a
Christian symbol of eternal life, is also a Habsburg emblem and may refer to Mi-
chol's royal patron.

Carreño here has remained faithful to the models established by Velázquez in
his attempt to avoid undue emphasis upon the sitter's unusual physical appearance.
Dressed in an elegant black waistcoat and breeches that monumentalize his small
form, his face and hands set off by white cravat and cuffs, Michol regards the view-
er with an air of dignified stolidity characteristic of Velázquez's dwarf series. Like-
wise reminiscent of Velázquez are Carreño's broken brushstroke and "impression-
istic" rendering of form.

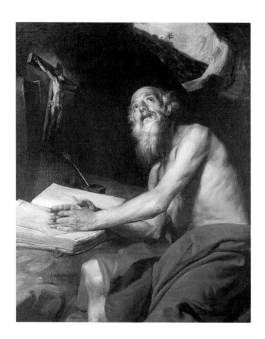

Juan Martín CABEZALERO
(1633-1673)
**Saint Jerome**, 1666
*San Jerónimo*
oil on canvas
Museum Purchase, Meadows
Museum Acquisition Fund
86.01

This rare signed and dated painting is by Juan Martín Cabezalero, a disciple of Juan Carreño de Miranda. Although short-lived, Cabezalero became one of the most important painters working in Madrid during the third quarter of the seventeenth century. Like many young artists of his generation, he had matured in the shadow of Velázquez, a heritage clear in works like this one, with warm hues and slightly blurred brushstrokes which recall the more daring "broken" brushwork of his famous predecessor.

Cabezalero portrayed Saint Jerome, the fourth century theologian and early hermit, living penitently in a cave in the desert, possessing only a crucifix and Bible. The painting's haggard central figure and pared-down rustic setting derive in part from representations of hermits and ascetics earlier popularized by Jusepe de Ribera, whose highly typical *Saint Paul the Hermit* is also in the Meadows Collection. Also reflective of Ribera's work are the richly textured paint surface, the dramatic tenebrism, and the characterization of the aged saint, with his furrowed brow, emaciated torso, and calm heavenward gaze.

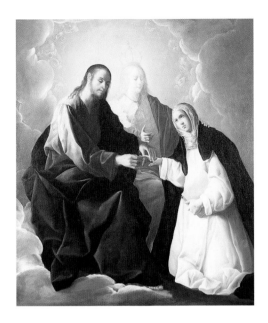

Francisco de ZURBARÁN
(1598-1664)
**The Mystic Marriage of**
**Saint Catherine of Siena,**
1640-60
*Los desposorios místicos de*
*Santa Catalina de Siena*
oil on canvas
Algur H. Meadows
Collection 67.14

Although the Sevillian painter Francisco de Zurbarán is best known today for his early tenebristic images of monks and saints, his oeuvre demonstrates the artist's continuing ability to modify his style to meet the expressive demands of his subject and the changing preferences of his patrons. This work exhibits a brightened palette and softened modeling which is both appropriate for its visionary subject and typical of the works produced in the later years of the artist's career, when public taste in his home city of Seville had turned toward gentler, more sentimentalized religious art.

The luminous ground and subtle color harmonies of this work set a fitting tone for its subject, the mystic marriage of Saint Catherine of Siena. The image is based on a vision experienced by the young Catherine, in which she was chosen by Christ as celestial spouse. Although Catherine's biography closely parallels that of her admired predecessor, Saint Catherine of Alexandria, the saint's black and white Dominican habit and her vision of an adult, not an infant Christ clearly identify the scene as that of the Sienese saint.

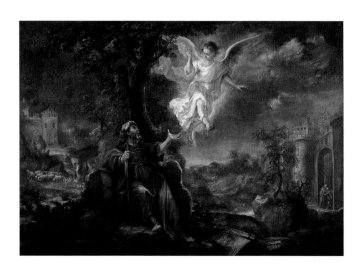

Juan de VALDÉS LEAL (1622-1690)
**Joachim and the Angel**, 1655-60
*Joaquín y el ángel*
oil on canvas
Museum Acquisition, by exchange  86.04

Juan de Valdés Leal was an important figure in seventeenth-century Seville.  Both a collaborator with and a rival to Murillo, with whom in 1672 he shared an important commission for the decoration of the chapel of the Hospital de la Caridad in Seville, Valdés Leal worked in a sketchy, idiosyncratic style which sets his paintings firmly apart from Murillo's charming idealizations.  This monumental canvas, although somewhat darkened with age, preserves the fiery color, sketchy brushstrokes, and sharply flickering highlights characteristic of the artist's dramatic approach to painting.

The work depicts the shepherd Joachim, who had been turned away from the Temple because of his childless marriage, as he receives word from an angel that his wife shortly will conceive.  According to the Apocryphal account, this child would be the Virgin Mary, the mother of Jesus.  This subject, although generally rare elsewhere in seventeenth-century European painting, remained quite popular in Spain, where its relevance to the doctrine of the Immaculate Conception must have struck a responsive chord.

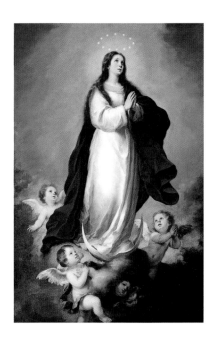

Bartolomé Esteban MURILLO
(1617/18-1682)
**The Immaculate Conception**,
1655-60
*La Inmaculada Concepción*
oil on canvas
Algur H. Meadows Collection 68.24

The image of the Immaculate Conception, which illustrated the doctrine of Mary's conception untainted by Original Sin, was ubiquitous in seventeenth-century Spain. It perhaps was never more beautifully depicted than in the work of the distinguished Sevillian painter Bartolomé Esteban Murillo, whose radiant *Inmaculadas* set a standard for his own century and beyond. This painting, apparently produced for the parish church at Loja, near Granada, presents one of Murillo's most refined interpretations of the motif: surrounded by a golden haze, the young Virgin has a monumental elegance which is set off by the ecstatic gestures of the *putti* who tumble admiringly at her feet. A drawing related to this work is preserved today in the British Museum.

Murillo's representations of the Immaculate Conception varied notably from the traditions established earlier in the century by his fellow Sevillian, the influential art theorist Francisco Pacheco. Whereas Pacheco's formula included a welter of symbolic flowers and objects intended to emblematize the Virgin's chastity, Murillo instead produced simplified, supremely harmonious compositions in which the young girl's grace and purity alone conveyed a symbolic message. This revisionist approach surely was facilitated by Pope Alexander's issue, in 1661, of the constitution *Solicitudo omnium ecclesiarum,* which had resolved earlier controversies by declaring indisputable the Virgin's immunity from Original Sin.

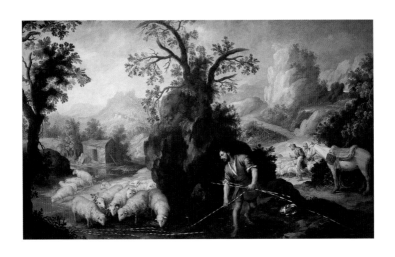

Bartolomé Esteban MURILLO (1617/18-1682)
**Jacob Laying Peeled Rods Before the Flocks of Laban**, ca. 1665
*Jacob pone las varas al ganado de Labán*
oil on canvas
Algur H. Meadows Collection 67.27

Among the least known of Murillo's many gifts is that of painting landscape, a talent which is nowhere better illustrated than in this monumental scene from the life of the Biblical patriarch Jacob. According to the Scriptural account (Gen. 30:25-43), Jacob's duplicitous father-in-law Laban offered the young man as a dowry all the beasts in his flocks which were born spotted or dark; he then secretly gave away all but the purest white animals. In retaliation, Jacob placed partially peeled wooden rods by the water where the flocks came to breed, provoking the birth of spotted offspring. The mountainous, lushly painted landscape, with its luminous silvery tones, recalls Dutch and Italian works probably encountered by Murillo in private Spanish collections.

This work was created as part of a series of narrative paintings of Jacob's life which was commissioned by the Marqués de Villamanrique. Although the works in the series all had left Spain by the early nineteenth century, five have now found their way into museum collections: two are in the Hermitage Museum in St. Petersburg, a fourth is in Cleveland, and a fifth has been acquired by the National Gallery of Ireland.

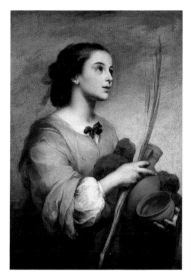
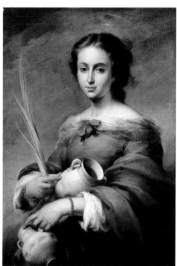

Bartolomé Esteban  MURILLO (1617/18-1682)
**Saint Justa**, ca. 1665
*Santa Justa*
**Saint Rufina**
*Santa Rufina*
oil on canvas
Algur H. Meadows Collection  72.04 and 72.05

Although Murillo had been trained in the sober, tenebristic manner characteristic of Sevillian painting in the first third of the century, the artist developed a new voice as he reached artistic maturity in the 1650s.  Nurtured in particular by a trip to Madrid in 1658, which brought him into direct contact with the cosmopolitan High Baroque traditions emergent in that city, he began to produce the freely painted, richly colored images for which he is best known.  These two devotional images, although smaller and more subtle than the artist's most famous compositions of the 1660s, exemplify the ravishing poetry and fluidity with which the artist could approach nearly any subject, whether religious or secular.

According to tradition, Justa and Rufina, the patron saints of Seville, were third-century pottery-sellers who secretly practiced Christianity, a religion still at that time proscribed by the Roman emperor.  Their refusal to sell their wares for use in pagan ritual revealed the sisters as Christians, and when they persisted in their faith, they were executed.  In reference to this, each sister holds ceramic vessels and a palm frond, a symbol of martyrdom.  The story is given fresh appeal and a charming contemporaneity by Murillo's characterization of the two early Christians as fresh-faced young *sevillanas,* whose elegant gowns and beads reflect seventeenth-century fashion.  These works are related in conception to a large single canvas produced by Murillo circa 1660 for the church of the Capuchins in Seville, which shows the two saints at full-length, flanking the cathedral's famous *giralda.*

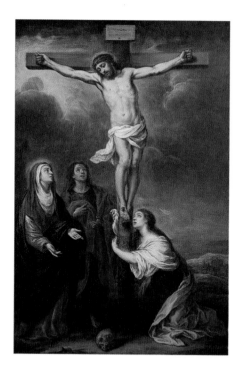

Bartolomé Esteban
MURILLO (1617/18-1682)
**Christ on the Cross with
the Virgin, Mary Magdalen,
and Saint John**, ca. 1670
*Cristo Crucificado con la
Vírgen, María Magdalena,
y San Juan*
oil on copper
Algur H. Meadows
Collection 67.11

Unlike Murillo's large-scale canvases, which generally were made for ecclesiastical settings, this small, lovely painting on copper was probably produced for private devotional use. In its simplified composition, dark and moody tonalities, and the eloquent gestures of Mary, Saint John the Evangelist, and the Magdalen at the foot of the Cross, it exemplifies Murillo's unerring ability to strike a balance between gracious execution and intense devotional spirit.

This work is closely related to a drawing by Murillo, now in a private collection in London, which depicts the corpus of the crucified Christ and is believed to have been made in preparation for this work. The survival of this drawing underscores the unusual meticulousness with which Murillo often planned his paintings, using preparatory sketches to create and refine his compositions before ever picking up his brush.

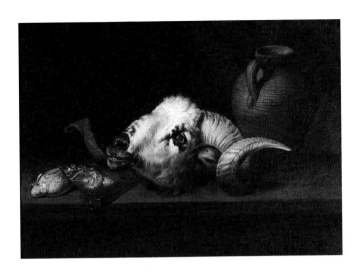

ANONYMOUS SEVILLIAN
**Still Life with Ram's Head,** 17th century
*Bodegón con una cabeza de carnero*
oil on canvas
Algur H. Meadows Collection 77.01

This expertly crafted painting is deeply rooted in the seventeenth-century Sevillian tradition of still-life painting, in which a limited number of objects, often fruit and food, are arranged in carefully balanced groupings against a dark ground. However, this painting differs in content from many typical compositions, which characteristically comprise a tempting array of candies, fruit, butchered meats, or artfully arranged game fowl. The rather grisly combination of a severed ram's head and testicles beside a knife and pottery jar may seem to the viewer more in keeping with Goya's subsequent, compelling visions of animals frozen in death, such as his *Still Life with Woodcocks* in the Meadows Collection.

Despite its unsettling subject matter, the painting exemplifies Sevillian taste for both exquisite composition and naturalistic observation. The objects form a zigzag pattern on a narrow ledge: the handle of the knife creates a diagonal line which is repeated in the tilt of the ram's head and the elegant curvature of its horn. Meanwhile, tenebristic light sets off such magnificently naturalistic details as the rough clay surface of the jug and the ram's slightly clouded eye.

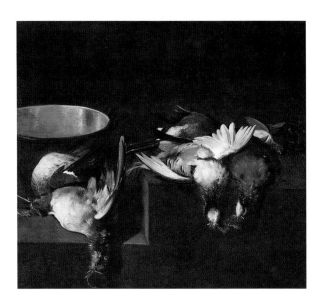

Pedro de CAMPROBÍN Passano (1605-1674)
**Still Life with Game Fowl**, 1653
*Bodegón con aves de caza*
oil on canvas
Algur H. Meadows Collection 72.03

Pedro de Camprobín Passano was Seville's leading painter of still life at the middle of the seventeenth century, creating quietly refined compositions with a charm and intimacy typical of the Sevillian school.  In this signed and dated painting, a large copper bowl and several game birds are carefully arranged on a simple stepped ledge, developing a compositional formula first popularized in the early seventeenth century by the Toledan still life painter Juan Sánchez Cotán.

Simple and understated, this work is sensitively composed and skillfully executed, especially in the fluent brushwork depicting the birds' disordered feathers and the sheen on the copper bowl.  A slight imbalance in the composition suggests that the canvas might have been cut down slightly on the left side; nonetheless, with its velvety modeling, warm hues, and intimate character, it exemplifies an easy elegance and affluence which, for economically pressured seventeenth-century Seville, would soon belong to the past.

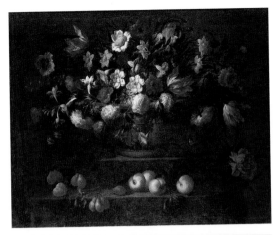

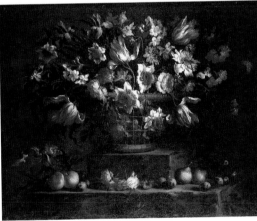

Juan de ARELLANO
(1614-1676)
**Still Life with Flowers,
Peaches, and Red
Plums,** 1650-76
*Florero con melocotones y
ciruelas rojas*
**Still Life with Flowers,
Pears, and Other Fruits**
*Florero con peras y otras
frutas*
oil on canvas
Museum Purchase,
Meadows Acquisition
Fund 81.01 and 81.02

Juan de Arellano was one of the most popular still life painters in Spain during the second half of the seventeenth century. While flower paintings such as those shown here had been produced by Northern painters since about 1600, *floreros,* as they came to be called, were uncommon in Spanish circles until mid-century, when Flemish still lifes began to be imported in increasing quantities. Inspired by these Northern models, Arellano painted numerous *floreros,* which were instrumental in popularizing this genre in his native land.

These still lifes depict monumental flower baskets of a type most characteristic of Arellano's mature years. Like many other such floral works, they probably served as overdoor or overwindow decorations in a grand private house in Madrid. With their abundance of brilliantly colored flowers, the paintings are remarkable for their dynamic energy, which animates each petal, stem, and leaf, combining with a rich and vivid palette to produce a vibrant vision of nature.

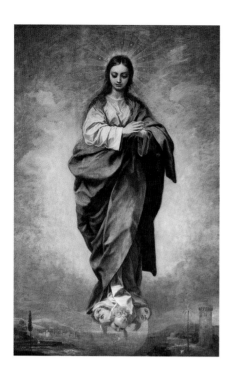

Juan de SEVILLA (1643-1695)
**The Immaculate Conception**,
1660-75
*La Inmaculada Concepción*
oil on canvas
Algur H. Meadows Collection
67.13

Juan de Sevilla was a native of Granada who spent most of his professional life working in his home city. There, he was strongly influenced by the more prominent Baroque painter Alonso Cano, who had settled in Granada in 1652 after a peripatetic career in Madrid and southern Spain. Cano's impact on Sevilla's work is clear in this painting, which depends closely on the numerous renditions of the *Inmaculada* produced by the elder artist, not only emulating its style, but virtually replicating its composition, its iconography, and even its patterns of drapery folds. A signed preparatory drawing for this work, now in the Biblioteca Nacional in Madrid, also reflects the Cano prototype.

A generation younger than his fellow Andalusian Bartolomé Murillo, Sevilla took a more conservative approach to the theme of the *Inmaculada,* reverting to the richly symbolic formula codified by Francisco Pacheco at the beginning of the century. Garbed in a white robe and blue mantle and crowned by twelve stars, the Virgin stands enveloped in brilliant light atop a translucent lunar sphere which is supported by a cluster of cherubim. The landscape below contains the traditional symbols of her purity, drawn from the Song of Solomon and the apocryphal Book of Ecclesiasticus: these include the Tower of David and a cluster of roses (Song 4:4), a fountain and locked garden (Song 4:12-15), a cedar (Ecclesiasticus 24:13-14), and an olive tree (Ecclesiasticus 24:19). A ship in full sail scarcely visible below the Virgin's feet may derive from a medieval liturgical song describing Mary as the "star of the sea."

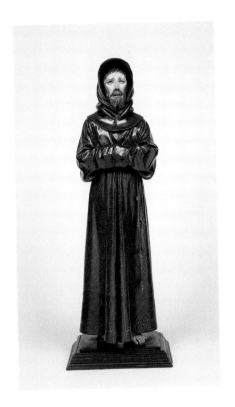

Follower of Pedro de MENA
**Saint Francis of Assisi,**
late 17th century
*San Francisco de Asís*
polychromed wood, bone/ivory
teeth, glass eyes
Museum Purchase, Meadows
Museum Acquisition Fund 90.05

This arresting sculpture depicts a legendary event in the history of Saint Francis, the gentle thirteenth-century ascetic and reformer. At some point after the saint's death, a legend arose that his body remained uncorrupted in its tomb in the crypt of his church at Assisi. A famous "eyewitness" description by a fifteenth-century investigator describes the saint's body standing upright on the sarcophagus, with hands clasped over the chest and open eyes raised to heaven. This figure, with its irregular, harrowed features, parted lips, and large, upturned eyes, evokes this description with a startling intensity.

The Meadows sculpture is a close variant of a famous figure of Saint Francis which was made for Toledo Cathedral by the seventeenth-century Castilian sculptor Pedro de Mena. Much of its impact derives from the incorporation, characteristic in Spanish polychrome sculpture, of a variety of materials, including ivory for the teeth and colored glass for the eyes, to give the work a naturalistic quality.

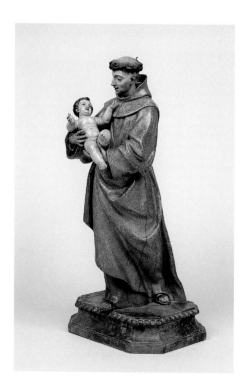

ANONYMOUS SEVILLIAN
**Saint Anthony of Padua
Holding the Christ Child**,
ca. 1700
*San Antonio de Padova con el
Niño Jesus*
polychromed wood and ivory
Museum Purchase, Meadows
Museum Acquisition Fund
89.07

Although this charming sculpture recalls the numerous votive figures of Saint Anthony so ubiquitous in seventeenth-century Spain, its dynamic, interactive composition endows the work with a strikingly narrative quality. It clearly was intended to evoke the legendary vision of Saint Anthony, whose religious meditations one day were rewarded by the appearance of the Christ child. The young saint's attitude of delighted surprise, lips parted and head cocked, suggests that the infant has only just materialized in his arms, interrupting his energetic forward stride.

Small sculpted figures of individual saints became popular in southern Spain, particularly in Granada, during the latter half of the seventeenth century. These often served as aids to private devotion, a role for which the joyous, intimate character of this work is particularly well suited.

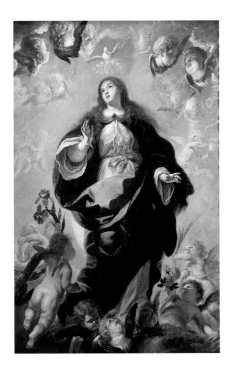

Antonio de PALOMINO
y Velasco (1655-1726)
**The Immaculate Conception**,
1695-1720
*La Inmaculada Concepción*
oil on canvas
Museum Purchase, Meadows
Foundation Funds 80.01

Antonio Palomino y Velasco, court painter to Charles II, has been called "the Spanish Vasari" for his extensive writings on art and artists. His *Lives of the Eminent Spanish Painters and Sculptors,* first published in 1724, still serves as a valuable resource for art historians. This scholarly reputation, however, sometimes obscures our knowledge of Palomino the artist, who served as a significant transitional figure between Spain's late Baroque and eighteenth-century painting traditions.

In this work, Palomino has infused a traditional representation of the Virgin of the Immaculate Conception with the drama characteristic of Late Baroque art in Spain. Surrounded by an explosion of floating cherubim, the Virgin assumes a dynamic *contrapposto* stance, arms and eyes uplifted to heaven as the folds of her blue mantle billow around her. In the lower half of the composition, *putti* proffer lilies and roses symbolic of the Virgin's chastity. While the composition exemplifies the monumental dynamism of the late Baroque in Spain, the softened palette of pale yellow, pink, and blue tones points the way to the new ideals of the eighteenth century.

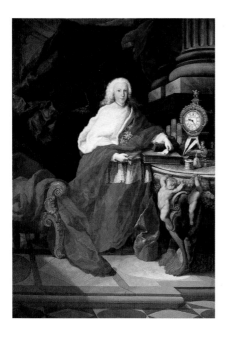

Antonio GONZÁLEZ RUIZ
(1712-1785)
**Portrait of the Cardinal Infante
Don Luis Antonio de Borbón**,
1742
*Retrato del Cardenal Infante Don
Luis Antonio de Borbón*
oil on canvas
Gift of Colonel C. Michael Paul
and The Paul Foundation,
New York 70.10

Despite his less than imposing appearance, the young subject of this opulent formal portrait eventually would achieve a stature more appropriate to his setting: he is the Infante Don Luis de Borbón (1727-1785), son of the Spanish Bourbon king Philip V and Isabella Farnese. Destined for the Church from an early age, Don Luis was made Cardinal-Archbishop of Toledo at the age of eight and Archbishop of Seville only six years afterward. Although the young prince's ecclesiastical career was soon ended by his attachment to more worldly pursuits, he later would establish himself as a significant patron of the arts and one of the first to commission portraits from the young Francisco Goya.

Don Luis appears here at the age of fifteen, enveloped in the crimson and ermine of a cardinal's robes and surrounded by magnificent books and furnishings, including an immense English clock. Although the work's painter, Antonio González Ruiz, seems to have been inspired by the majestic ecclesiastical portraits of the French artist Hyacinthe Rigaud, he was unable to disguise the incongruity of the contrast between the small, pale boy and his monumental trappings of authority.

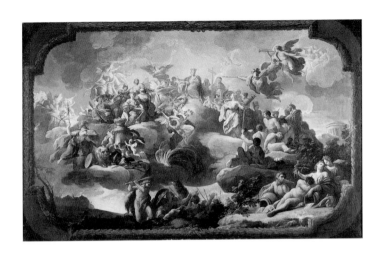

Antonio GONZÁLEZ Velázquez (1723-1793)
**Allegory of the Spanish Monarchy**, 1753-64
*Alegoría de la monarquía española*
oil on canvas
Museum Acquisition, by excchange  79.02

Before undertaking the demanding task of painting a full-scale fresco, most eighteenth-century artists first produced a series of preliminary studies. These usually included oil sketches of the entire composition, which provided an intermediate step between the artist's initial drawings for the work and the final monumental version.  This sketch may have been produced in preparation for a ceiling fresco in the Bourbon royal palace in Madrid, on the decoration of which González Velázquez was engaged for several years.  Unfortunately, there is no record that a fresco based upon this composition ever was completed by the artist.

The sketch represents Spain as a crowned figure surrounded by other allegorical personages, including representations of Justice and Religion.  A lion and castle representing Spain's important central region of Castile appear to the lower left. At the bottom of the composition, the trademark attributes of club and lion's skin distinguish the Roman hero Hercules, the legendary ancestor of the Spanish monarchical line.

Francisco BAYEU y Subías
(1734-1795)
**The Vision of Saint Francis in
La Porciuncula**, ca. 1781
*Visión de San Francisco en La Porciúncula*
oil on canvas
Algur H. Meadows Collection 75.05

Francisco Bayeu probably is best known in this century as an early teacher, colleague, and brother-in-law of Francisco Goya, an association which tends to overshadow Bayeu's own significant artistic accomplishments. A painter in both oil and fresco, Bayeu was brilliantly successful both at court and in his work for the religious foundations of Madrid. His characteristic style, which blends the pale hues and bravura execution of the Rococo with the firm-edged solidity of Neoclassicism, is fully appreciable in this gem-like canvas.

This oil sketch is a preparatory version of the main altarpiece of San Francisco el Grande in Madrid and the work which won this influential commission for Bayeu. It depicts an event from the life of Saint Francis, who was visited by a vision of Christ and the Virgin as he undertook the renovation of the abandoned Benedictine monastery of La Porciuncula, the foundation that would become the mother house of the new Franciscan order. Firm modeling, cool hues, and a balanced serpentine composition give this sketch a monumental clarity unexpected in a preparatory work.

Mariano Salvador de MAELLA
(1739-1819)
**Spain and the Four Parts
of the World**, ca. 1792
*España acompañada de las cuatro
partes del mundo*
oil on canvas
Museum Purchase, Meadows
Foundation Funds
(given in honor of Dr. William B.
Jordan, Museum Director
1967-1981) 81.11

Mariano Maella, a protégé of the Bohemian artist Anton Rafael Mengs, participated in the decoration of many major buildings in Madrid. Like that of his colleagues Antonio González Velázquez and Francisco Bayeu, Maella's work displays the light-filled tones and spirited execution characteristic of the decorative traditions so much appreciated in Bourbon Spain.

This small canvas was a preparatory sketch for a fresco in the ballroom of the Casita del Labrador in the royal palace of Aranjuez. It represents Spain in the form of an enthroned figure attended by allegorical figures of Europe, Asia, Africa, and America, the latter of which includes a Native American wearing a feathered headdress. The sketch effectively suggests the intended spatial effects of Maella's final work, giving the illusion of a heavenly vault soaring upward toward the center of the composition.

Vicente LÓPEZ y Portaña
(1772-1850)
**Saint Vincent Martyr Before Dacius,**
ca. 1796
*San Vicente Mártir delante de Daciano*
oil on canvas
Museum Purchase, Meadows Museum
Acquisition Fund 94.02

Vicente López, whose distinguished career spanned the first half of the nineteenth century and included three years as the director of the Prado Museum (1823-26), is well known today for his sleek, minutely detailed portraits of the Spanish upper classes. However, as this youthful painting shows, the Valencian-born artist had his earliest training in the late Baroque traditions of the eighteenth century.

This oil sketch was a preparatory work for a monumental altarpiece, today lost, which the artist created for Valencia cathedral circa 1796. It depicts Saint Vincent, an early fourth-century deacon of the then-outlawed Christian church, confronted by his persecutor, the Roman pro-consul Dacius. Refusing a pagan idol proffered for his worship, Vincent gestures dramatically heavenward, where angels await with his martyr's crown. The painting retains its original stretcher and has remained in remarkably good condition, preserving rich, brilliant tones, a sumptuous paint surface, and a bravura execution which demonstrate the twenty-four-year-old painter's early mastery of his craft.

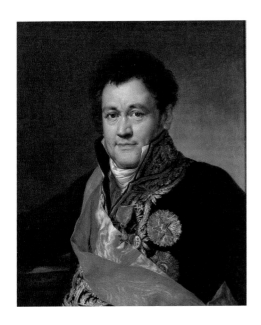

Vicente LÓPEZ y Portaña
(1772-1850)
**Portrait of Baron Mathieu
de Faviers**, 1812
*Retrato del Barón Mathieu
de Faviers*
oil on canvas
Algur H. Meadows Collection
65.24

Although Vicente López was lauded by the Spanish monarchy for the distance he had maintained from the occupying regime of Joseph Bonaparte (1808-13), this portrait of a French general suggests that López, like his older contemporary Francisco de Goya, might not have been over-exclusive in his choice of patrons. The Baron's prominent military decorations include a badge with five crosses, identifying him as a Knight of the Equestrian Order of the Holy Sepulchre, and two others associated with the Royal Order of Spain, which had been founded by Bonaparte himself in 1809. The Baron's alert, self-assured bearing implies a character in keeping with these honors.

López had begun his artistic study early, entering the Real Academia de Bellas Artes de San Carlos in Valencia at age thirteen and the Real Academia de San Fernando in Madrid four years later. He returned to Valencia to begin his profession, but by 1814 he had been summoned to the court of Ferdinand VII as Pintor de Cámara, soon afterward sharing the title of First Court Painter with Francisco Goya. López remained in Madrid until the end of his life, working subsequently for Queen Isabella II. Although his prolific artistic output also included religious and history paintings, he was especially sought after for his portraiture, which had a special appeal for its suave realism and rich coloristic effects. Such skills are here put to work at their highest level to replicate the Baron's florid features, his glittering decorations, and his iridescent sash.

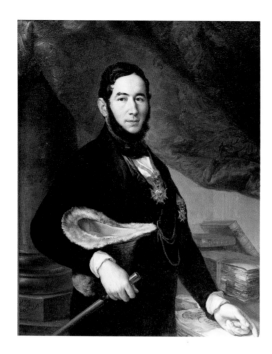

Vicente LÓPEZ y Portaña
(1772-1850)
**Portrait of the Marqués
de Nevares**, 1840
*Retrato del Marqués
de Nevares*
oil on canvas
Algur H. Meadows
Collection 65.25

The Spanish nobleman portrayed here, the Marqués de Nevares, was president of the *junta* (city council) of Seville during the Napoleonic occupation of Spain. In reference to his administrative responsibilities, he stands surrounded by legal papers and charters. Many of these documents literally are bound by the same red tape that today bears the proverbial blame for bureaucratic delays.

Vicente López's much-admired illusionistic abilities are at their finest in this work. Exquisitely tactile details such as the hard, glinting handle of the sitter's cane, the sparkling enamel of his medals, and the silken fur of his hat brim bring life to this otherwise rather sober figure. The green brocaded drape that serves as a backdrop, by contrast, is handled more loosely and lushly, recalling the artist's early facility in the grand traditions of the late Baroque.

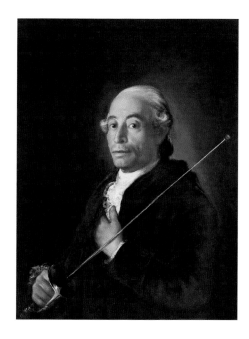

Francisco José de GOYA
y Lucientes (1746-1828)
**Portrait of Francisco
Sabatini**, 1775-79
*Retrato de Francisco Sabatini*
oil on canvas
Algur H. Meadows Collection
67.03

Born in the Aragonese town of Fuendetodos in 1746, Francisco Goya passed through several years of struggle in Zaragoza and Madrid before an appointment to the Royal Tapestry Factory in Madrid in 1775 launched his career in earnest. At about this time, the artist also began to receive commissions for private portraits, which stand among his most incisive and intriguing works. This relatively early likeness, painted shortly after Goya's appointment in Madrid, is one such early commission and exemplifies the artist's emerging gifts as a portraitist. The large eyes, heavy brows, and coolly appraising glance of the sitter, coupled with the capped epée that he holds at a sharp angle across his body, endow him with a formidable and unforgettable presence.

The identity of Goya's sitter has been debated, but he bears a strong resemblance to the dapper, heavy-browed man who appears in the background of Goya's well-known *Portrait of the Count of Floridablanca,* painted in 1783 (Banco de España, Madrid). This individual has been identified as the Italian architect Francisco Sabatini, who had come to Spain from Italy in 1760 to become First Architect to Goya's first royal patron, King Charles III. If this identification is correct, it says much for the level of society that had begun to patronize the young artist in the years just after his arrival.

Francisco José de GOYA y
Lucientes (1746-1828)
**Yard with Madmen**, 1794
*Corral de locos*
oil on tin-plated iron
Algur H. Meadows Collection
67.01

This small but surpassingly powerful work was produced at the most critical juncture of Goya's long career. In the last months of 1792, the artist suffered a mysterious illness which left him physically debilitated and permanently deaf. During his recuperation in 1793-1794, Goya undertook a series of small-scale paintings on metal in which, as he wrote to a colleague at the Real Academia de San Fernando, "I dedicated myself to painting a suite of cabinet pictures, in which I have succeeded in making observations which ordinarily are not allowed in commissioned works, where caprice and invention have little part to play." Of the twelve paintings in this series, Goya's letters refer specifically only to one, the Meadows painting, which he described as "a yard with lunatics, in which two nude men fight with their warden beating them… (it is a scene I saw in Zaragoza)." The eyewitness character implied by this comment links the scene with other works by Goya which share its quality of *reportage,* particularly the *Disasters of War* prints, in which one especially shocking scene bears the affirmation, "Yo lo ví" ("I saw it"). The jeering, confrontational postures of the madmen; their stage-like, claustrophobic setting; and the nearly blinding effect of the white light of the sky as it pours over the high wall of the courtyard only heighten this effect.

The whereabouts of this painting had been unknown since December 1922, when it was offered for sale at the Hotel Druôt in Paris. Its acquisition by the Meadows Museum in 1967 marked the painting's return to the public sphere. A thorough conservation undertaken in 1993 included the removal of a layer of grimy varnish, which revealed a surprisingly delicate paint surface in which translucent, smoky browns and grays, enlivened with touches of blue and green, are set against glowing passages of whitish impasto.

Francisco José de GOYA y
Lucientes (1746-1828)
**Unfinished Portrait of a Lady**,
1804-08
*Retrato inacabado de una dama*
oil on canvas
Algur H. Meadows Collection
67.04

Goya's portraits of female sitters are of a tremendous variety, ranging from vacuous, doll-like Rococo figures to likenesses of a startlingly sensuous dynamism. This portrait of an unidentified lady, painted during Goya's maturity, was never finished: only the face, neck and shoulders have been fully modeled, while the arms and torso are suggested solely by lightly sketched lines on an unmodulated brown ground. Nonetheless, it is a compelling characterization which attests to Goya's enduring gifts as a portraitist. Most remarkable is the unsettling contradiction between the young woman's soft, pliable features and her distrustful, even sullen, outward glance. The limited palette, consisting mainly of browns, grays, and white, is found in many of the private portraits Goya painted at this time.

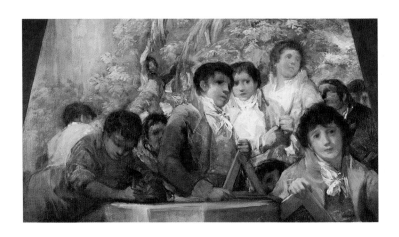

Francisco José de GOYA y Lucientes (1746-1828)
**Students from the Pestalozzian Academy [fragment]**, 1806-07
*Estudiantes de la Academia Pestalozzi [fragmento]*
oil on canvas
Algur H. Meadows Collection 67.24

This lively fragment is all that remains of a monumental painting by Goya which depicted the dedication of the Royal Pestalozzian Academy, an innovative new public school, by the Prime Minister of Spain, Manuel Godoy. The original composition, now known only from a copy attributed to Agustín Esteve (Real Academia de San Fernando, Madrid), depicted a full-length figure of Godoy, who holds a copy of a pedagogical book by the progressive educator [J.H.] Pestalozzi and stands before a Classical structure and a small throng of students, part of which is preserved in the Meadows fragment. The selection of Goya to represent this controversial and short-lived Prime Minister reflects the artist's centrality in the court of Charles IV, a stature surprisingly little altered under the various regimes that would follow that ruler's abdication in 1808.

This fragment depicts several attentive boys holding wooden rulers and other pedagogical implements while more carefree classmates frolic behind them. Because these figures bore relatively little relevance to the work's central image, Goya was free to treat this section of the canvas with lush colors and loose, evocative brushstrokes reminiscent of an oil sketch. Such freedom demonstrates the audacious liberty with which the artist could approach even the most conventional of subjects.

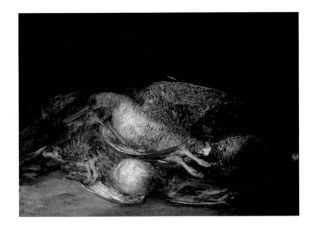

Francisco José de
GOYA y Lucientes
(1746-1828)
**Still Life with
Woodcocks,**
1808-12
*Bodegón de
chochaperdices*
oil on canvas
Algur H. Meadows
Collection 71.01

Goya came to still life relatively late in his career, making his first known efforts in this area when he was beyond the age of sixty. To these works, he brought the same timelessness and unrelenting honesty that characterize his best work in any medium or genre. This painting is one of an original group of twelve still lifes, ten of which are still known today, which were painted by Goya during the years 1808-1812. Dedicated to themes traditional to the genre, such as fruit, fish, and dead game, they remained in Goya's hands throughout his life and may have been hung as a group in his house on the Calle de Valverde, where he lived until 1819. Thus, like the Black Paintings that he later produced for the walls of the Quinta del Sordo, these works represent an undertaking more experimental, more personal, and more emotional than those made for the public.

Goya's still lifes should not be considered outside the context of the cataclysmic Peninsular War, which the artist both commemorated and lamented in his great series of prints, "Disasters of War (*Desastres de la Guerra*)." The tragic themes of suffering, carnage and death that resound in the print series also infuse *Still Life with Woodcocks* and its related works. In contrast to established still life traditions, in which opulent heaps of fruit or game are endowed with a picturesque charm, Goya here presents birds violently put to death, their wings still arched in the struggle for life, their necks intertwined as if seeking mutual comfort. Abrupt transitions from muscular impasto passages to fine, iridescent glazes lend the work an unexpected beauty, as well as an expressive pathos.

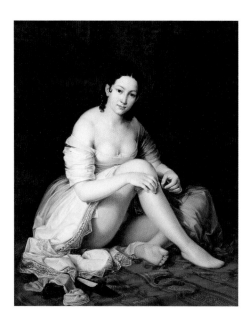

Antonio María ESQUIVEL
(1806-1857)
**Woman Removing Her Garter**, 1842
*Mujer al quitarse la liga*
oil on canvas
Algur H. Meadows Collection
65.16

Antonio Esquivel was born and educated in Seville, but in 1831 he relocated to Madrid, where his work was well received. A few years later, however, Esquivel's career was interrupted when he lost his sight as a result of an attack of herpes suffered in 1838. The depression that followed this blow was accompanied by several attempts at suicide and was mitigated only when sympathetic donations from the artistic circles of Madrid sent the artist abroad to a famous German eye specialist. His vision restored in 1841, the artist returned triumphantly to work.

As is clear from the inscription in its lower left corner, this work was painted in 1842, very shortly after the artist recovered his vision. It represents a subject which at the time was somewhat unusual in Spanish circles, that of an attractive woman observed coyly undressing in her boudoir. One of a series of works which Esquivel painted of the same young model, it possesses a sensuous tactility and a candid eroticism which suggest that it was made for a very private setting.

Genaro PÉREZ VILLAAMIL
(1807-1854)
**Romantic Landscape**, 1843
*Paisaje romántico*
oil on canvas
Algur H. Meadows Collection 65.31

In its emphasis on atmosphere, this modest painting reflects an internationally shared interest of mid-nineteenth-century landscape painters. The nuanced tonal variability of which oil paint is capable is exploited to evoke effects of light, mist, and cloud in a landscape generalized toward the Romantic. A recent cleaning of this work has revitalized the cool mauve and lavender tones so important to these effects.

There exists a diary entry by the artist, for January 21, 1843, which almost certainly refers to this painting. Rather than going out at all, the artist executed this work in a single day spent inside his studio. In his own view the landscape reflected the manner of fourteenth-century Flemish painting (something an art historian might question), and seems also to have echoed in his mind with memories of a canal in the Louvain. Such mixed historical and experiential associations epitomize the Romantic approach.

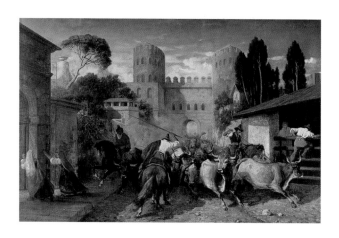

Eugenio LUCAS Velázquez (1817-1870)
**Cattle Drive**, 1852
*Manada de reses*
oil on canvas
Algur H. Meadows Collection 65.26

Eugenio Lucas Velázquez is recognized today as an admirer and faithful emulator of his immediate predecessor, Francisco Goya. However, this signed work, painted when Lucas lived briefly in Paris, lacks the Goyesque impasto and dark tonalities for which his work tends to be known. Its light tones and carefully finished contours, though still enlivened by a certain freedom of execution, demonstrate that the artist was equally at home in the traditions established by more conventional academicians, such as Vicente López.

Some attempt has been made to identify a specific Roman gate before which the cattle drive takes place, a detail which could place this work in a recognizable location. However, although it may have been inspired by the Roman and medieval ruins that even today remain incorporated into the walls of many Spanish towns, the gate is more likely an imaginary and romanticizing addition, intended to lend the scene a certain picturesque charm. The gate also plays a powerful role as a high, immobile backdrop for the flying hooves and gesticulating riders that are set in motion below.

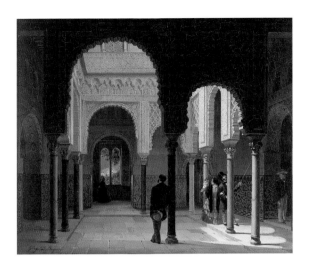

Joaquín DOMÍNGUEZ BÉCQUER
(1817-1879)
**Ladies and Gentlemen Visiting a Patio of the Alcázar of Seville**, 1857
*Visita a un patio del Alcázar de Sevilla*
oil on canvas
Algur H. Meadows Collection 65.15

Joaquín Domínguez Bécquer was a member of an illustrious artistic and literary family of nineteenth-century Seville, which included the well-known poet Gustavo Adolfo Bécquer. With his brother and fellow painter José (1805-1845), Joaquín helped to initiate an essentially Andalusian genre of painting known as *costumbrismo* (from the Spanish *costumbre,* or "custom"), which set out to depict the life and habits of his contemporary Spain.

This scene depicts tourists on a visit to the Alcázar of Seville, an Islamic palace constructed at the end of the twelfth century and renovated with the aid of Islamic craftsmen by the Christian King Peter the Cruel in the fourteenth century. The setting can be recognized as the Patio de las Muñecas, one of the richest structures of the complex. The artist's interest in the Alcázar might have stemmed not only from the building's fame as a nineteenth-century tourist attraction, but also from a concern for Spain's neglected Islamic heritage. Such interest might have been logical on the part of a painter who also served as director of the Sevillian Commission for Artistic Monuments, an organization charged with the restoration of the Alcázar.

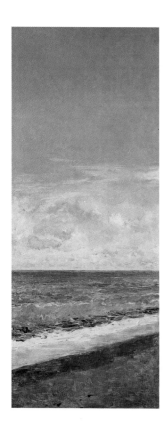

Mariano FORTUNY i Marsal (1838-1874)
**Beach at Portici**, 1873-74
*Playa en Portici*
oil on canvas
Algur H. Meadows Collection 71.05

The short-lived but prolific painter Mariano Fortuny traveled widely throughout his career, working in such diverse locations as Barcelona, Rome, Morocco, and Paris. His individualistic style, which blends a vibrant bravura technique and unerring compositional skill with an optical realism suggestive of French Impressionism, foreshadows the groundbreaking artistic experiments of the approaching century.

Although Fortuny may be best known for his orientalizing visions of North Africa and other such "exotic" subjects, he was also adept at landscape. This unusual seascape, painted shortly before Fortuny's early death at the age of thirtysix, isolates for the viewer a narrow vertical strip of a light-filled, uninhabited beach. This unconventional framing of a subject more traditionally rendered as a sweeping horizontal vista reduces the slices of sand, sea, and sky to virtual abstraction.

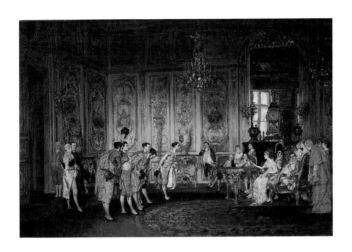

Antonio CASANOVA y Estorach (1847-1896)
**Favorites of the Court** *(Les favoris de la cour),* 1877
*Los favoritos de la corte*
oil on canvas
Algur H. Meadows Collection 65.12

*Favorites of the Court* represents a category of painting which had vast popularity in Europe throughout the nineteenth century: the genre costume piece. A specifically Spanish flavor is provided by the bullfighters and by certain details of costuming among the members of the court of Ferdinand VII, a few of whom might be gently satirized. In the interest of "historical accuracy," Casanova had obtained permission to work at Fontainebleu between October 15 and November 1, 1876. The room represented here is the Salle du Conseil, though Casanova made some modifications in both the architecture and the furniture. The Spanish monarch whose court is shown, Ferdinand VII, is not known ever to have been at Fontainebleu.

Characteristic of the costume piece is a highly competent execution and an artistic viewpoint permeated by layers of insincerity. Anecdote overrides any internal pictorial energy or genuine emotion, while story line is tailored toward a bourgeois audience for whom careful finish equaled genuine excellence. Casanova was especially popular among nineteenth-century English collectors, one of whom bought this work from the Paris Salon of 1877.

Luis JIMÉNEZ ARANDA
(1845-1928)
**Lady at the Paris Exposition**, 1889
*Dama en la Exposición de París*
oil on canvas
Algur H. Meadows Collection 69.24

In this painting Luis Jiménez Aranda combined his earlier academic training with a recently acquired sense of Impressionist touch and color. The precisely painted, though quite fashionable, lady reflects the costume and history painting mode in which the artist was trained, first in Seville and then in Rome. The brighter and more loosely painted view of Paris and the just-completed Eiffel Tower indicate that Jiménez, resident in France since 1876, had assimilated with considerable success the newer artistic and coloristic vision associated with Impressionism. In fact, Jiménez eventually settled at one of the sites key in the development of Impressionism, Pontoise.

The anecdotally-directed tradition from which Jiménez sprang is apparent in the implied story evoked here by the newspaper and beer mug on the table at left, which combines with the woman's pensive expression to suggest that one witnesses only a part of a more complex episode. The original color of the Eiffel Tower, along with the freshly shining, domed central pavilion of the Paris International Exposition of 1889, are freely painted in a sparkling, vibrant palette.

José JIMÉNEZ ARANDA (1837-1903)
**The Smokers**, 1890
*Los fumadores*
oil on wood panel
Algur H. Meadows Collection 65.23

Beginning in 1881, José Jiménez Aranda spent nine years in Paris before return-
ing permanently to Spain. In Paris he assimilated elements of the style of the emi-
nently successful academic genre painter Meissonier, such as the relatively light
though closely controlled touch with which he achieved his naturalistic atmos-
pheric quality and exactly specified textural effects. He had earlier been encour-
aged in his pursuit of "waistcoat pictures" (so named for the late eighteenth cen-
tury garment prominently featured here and in many such evocations of the past)
by contact in Rome with the most successful Spanish practitioner of the genre,
Mariano Fortuny.

Back in Spain during the early 1890s, Jiménez followed the trend away from
costume pieces toward a greater realism, and his later important works concern
contemporary subjects; these paintings are executed in a drier but still atmospher-
ic version of his precise rendering. From 1897 onward Jiménez was in his home
city of Seville, where he taught painting and was a fellow of the Sevillian Academy
of Fine Arts.

Raimundo de
MADRAZO y Garreta
(1841-1920)
**Self-Portrait**, 1901
*Autorretrato*
oil on canvas
Algur H. Meadows
Collection 73.01

Raimundo de Madrazo y Garreta was a member of a distinguished artistic dynasty, which included his grandfather José de Madrazo (1781-1859), a Neoclassical painter; his father, Federico de Madrazo y Kuntz (1815-1894), one of Spain's leading portraitists; and his uncles, the art historian Pedro de Madrazo y Kuntz and the architect Juan de Madrazo y Kuntz. Raimundo's own son Federico Madrazo Ochoa (1874-1935) and his brother Ricardo Madrazo y Garreta (1852-1917) were also active as painters, and the family's artistic heritage was extended even further when Raimundo's sister Cecilia married the Catalan painter Mariano Fortuny y Marsal.

Born in Rome in 1841 and trained in painting by his father, Raimundo de Madrazo spent little of his working life in Spain. He lived for many years in Paris, and spent some time also working in New York, where he was well received by the city's upper classes. This portrait was produced there for Eva Purdy Thompson, an American first cousin to Winston Churchill, who recorded on the painting's reverse: "This portrate (sic) of Raymound (sic) G Madrazo was given to me by him & his wife Maria on Jan 11. 1901 the day after it was made by him in his studio at 59 W. 45th Street, New York City, it is greatly prized & beloved by me. Eva Purdy Thompson." The painting, which despite a loose, unfinished quality endows the artist with a vivid presence, exemplifies the relaxed yet observant approach to portraiture at which Raimundo Madrazo excelled.

Emilio SÁNCHEZ PERRIER (1855-1907)
**River Landscape**, 1880-1907
*Paisaje fluvial*
oil on wood panel
Algur H. Meadows Collection 71.02

During the last quarter of the nineteenth century, Emilio Sánchez Perrier emerged as the leader of a thriving school of landscape painting in the city of Seville. A student of Joaquín Domínguez Bécquer, Sánchez Perrier worked for a time in France, where this landscape was painted. Although he worked contemporaneously with many French Impressionists and shared their interest in *plein air* (outdoor) landscape painting, Sánchez Perrier eschewed the free brushwork and evocative color of Monet and Pissarro to pursue a more academic style.

The minutely realistic aspects of paintings such as this one have led some scholars to posit that Sánchez Perrier might have used the recently-perfected medium of photography to develop models for his landscapes. Certainly, this scene's seemingly spontaneous framing and carefully modulated planes of focus suggest an awareness of photographic techniques. The work's gracious composition, with its lyrical, curvilinear echoing of vista and reflection, bears witness to the artist's talents with palette and brush.

Joaquín SOROLLA y Bastida (1863-1923)
**View of Las Pedrizas from El Pardo,** 1907
*Vista de Las Pedrizas desde El Pardo*
oil on canvas
Algur H. Meadows Collection 65.37

Sorolla is famous for his sun-drenched light. While this light has its most eye-blinding brilliance in Sorolla's seashore and beach paintings, the same intense illumination breaks through the clouds here. Moving through darkness like a blazing knife, this Iberian light is at home in Texas, where a similar solar concentration fills many of our days. The effects in nature which Sorolla sought were instantaneous and rapidly changing. To capture these in the dense material of oil paint the artist used patterned patches of color and juicy pigment laid on with broad brushstrokes that sought more to suggest than to define too fully.

Fame and success rewarded Sorolla, who was the best-known Spanish artist of his day. It was at a 1908 exhibition of his work at London's Grafton Galleries that Sorolla met the American Archer M. Huntington, founder of the Hispanic Society of America. This led to a large exhibition of Sorolla's work at the Society which was attended by almost 160,000 visitors, a remarkable number for that era. The most important result of the London meeting was a commission for fourteen large canvases representing the regions of Spain, which are still among the highlights of the Hispanic Society headquarters in New York.

Darío de REGOYOS y Valdés (1857-1913)
**Thaw in the Pyrenees**, ca. 1886
*Deshielo en los Pirineos*
oil on canvas
Gift of the Meadows Foundation, Inc. 66.13

The international outlook that rejuvenated Spanish painting toward the end of the nineteenth century informs the work of Darío de Regoyos. Born in Asturias, Regoyos first studied art in Madrid, then in 1879 undertook the first of several European journeys which took him to France, England, the Netherlands, and Belgium, where his artistic contacts included Théo van Rysselberghe and Constantine Meunier. Unlike many more frankly expatriate Spanish artists, however, Regoyos remained dedicated to Spain and Spanish subjects, returning frequently to paint there, exhibiting in Madrid and Barcelona, and settling ultimately in Granada, then Barcelona, after 1910.

The challenge of capturing the varied and austere beauty of the Spanish landscape was of enduring interest for Regoyos. His *Thaw in the Pyrenees* evokes the rocky alpine heights of northern Spain with a refreshing clarity and luminosity. Unusual in its focus on a shallow field of foreground elements rather than a distant vista, the work allowed Regoyos to give free play to his lyrical compositional sense, exquisitely balancing the dark forms of the twisted pine and bare ground against luminous patches of snow and sky. This painting, which was at one time owned by Camille Pissarro, was shown in Brussels in 1886 at the third salon of *Les XX,* an international avant-garde group of which Regoyos was a founding member.

Joaquín MIR Trinxet (1873-1940)
**Catalan Landscape**, before 1928
*Paisaje catalán*
oil on canvas
Algur H. Meadows Collection 65.29

Exhibited in Barcelona at least as early as 1928, *Catalan Landscape* combines a texturally focused painting technique with an on-the-spot way of looking. The result, however, cannot be pigeon-holed into an "ism", nor could it be exactly placed in time from the image itself. The space is relatively shallow; the richly textured paint use calls attention to the canvas surface in a way that contradicts conventional illusionism; color units are enough broken apart that the viewer must make a focal effort to fuse them. All of these qualities indicate that Mir was alert to innovations in the art of painting made between 1870 and 1905. From the multiple aspects of this awareness, however, he has created an individual style which emphasizes the intense, vibrant, and starkly contrastive Iberian light.

Ignacio ZULOAGA (1870-1945)
**The Bullfighter "El Segovianito",**
1912
*El Toreador "El Segovianito"*
oil on canvas
Algur H. Meadows Collection 71.08

This life-sized portrait has a poster-like directness of pose, shapes, and color patterning. It was painted just at the end of an era of great poster design by major artists, most notably Toulouse-Lautrec in France and Ramon Casas in Spain. In Paris himself in 1889, Zuloaga must have seen such posters enlivening the city's kiosks. Additionally, in the near-strident color juxtapositions and flattened modeling used in *El Segovianito,* Zuloaga further indicates his awareness of a contemporary art milieu he did not altogether embrace.

Zuloaga was noted as a society portraitist. The same incisiveness of line and clarity of overall image which gave his portraits a quality easily recognized and therefore desired by persons of fashion is seen here as well. The bullfighter, an authentic hero in Spanish culture, is thus lionized. In this case, however, the artist has painted from some direct experience. For a brief period in his youth Zuloaga had tried bullfighting, but stopped at his mother's urging.

This painting was first exhibited publicly in the United States during 1916 and 1917 in what is known as the Lydig Exhibit. The catalogue for this presentation contained an enthusiastic foreword about Zuloaga by the illustrious, and somewhat artistically kin, John Singer Sargent. In that catalogue the painting's model is referred to as "a young Segovian toreador of distinct promise." This 1916-1917 exhibit, which went to eight cities in the United States, was the first public showing of *El Segovianito.*

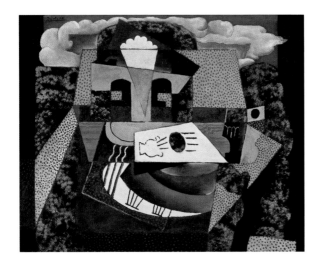

Pablo Ruiz
PICASSO
(1881-1973)
**Still Life in a
Landscape**, 1915
*Naturaleza muerta
en un paisaje*
oil on canvas
Algur H. Meadows
Collection 69.26

The introduction of *papier collé* into cubist works in 1912 began the radical stylistic shift from the initial, analytic phase of Cubism to the second, synthetic phase. The earlier form of Cubism, analytic (1909-1912), had been characterized by a limited color range, faceted and geometrically broken shapes evocative of a multiplicity of viewpoints simultaneously seen, and a shallow but varied pictorial space. The synthetic mode (1912 and after) brought numerous and textured colors back, introduced larger formal units that were layered and flat rather than interknit and ridged, and made pictorial space both shallower and more ambiguous than had analytic Cubism.

The importance of collage (in which a variety of materials is cut up and pasted onto the picture surface) in synthetic Cubism can be seen in the Meadows Picasso. While *Still Life in a Landscape* has no actual collage elements, Picasso's approach to representing the images is collage-like: segments are clearly separated, some colored areas have patterns which seem almost printed, and the pictorial space has the shallow, overlapped nature of the collage.

*Still Life in a Landscape* is rich in newly elaborate and complex coloristic and compositional devices Picasso introduced into his work in 1914 and 1915. Interior and exterior and foreground and background are intentionally confounded and interwoven. This is done especially through the conventionalized foliage – itself reminiscent of printed wall paper – and the lobed cloud forms, which appear to move at random through both the pictorial space and the solidity of the still life objects. Another painted device which simulates printed paper and also makes spatial reference more ambiguous is the extensive use of panels executed in dots recalling pointillism.

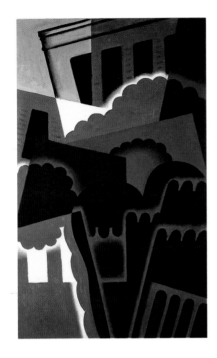

Juan GRIS (1887-1927)
**Cubist Landscape**, 1917
*Paisaje cubista*
oil on wood panel
Algur H. Meadows Collection 67.25

A Spanish artist whose professional life, like that of Pablo Picasso, was focused in Paris, Juan Gris (born José Victoriano González Pérez) developed a distinctively personal mode of synthetic cubism. Surfaces often have a glossy, metallic look and edges are given knife-like definition, shapes overlap and retain a relatively unambiguous individual identity, and a rigorous sense of orderliness pervades the composition.

*Cubist Landscape* was completed at a dark moment for Gris, the result of his being in Paris during the latter part of World War I. In the spring of 1917 the artist had written his friend Maurice Raynal, "You can't imagine the feelings of gloom and disgust to which I have been prey for some time now . . . Paris is not much fun I assure you despite the sun and the arrival of General Pershing."

At the time he painted *Cubist Landscape* Gris was apparently re-examining his art. Some works of 1917 are compositionally complicated and brightly colored, recalling works from 1913 to 1915. Others, including the Meadows painting, have an austerity of color and composition that reflects the artist's darker feelings at this time. Closest to *Cubist Landscape,* which in its stark focus is rather unusual in Gris's body of work, are some 1917 pencil drawings of Place Ravignan and a 1916 oil, *The Garden.*

*Cubist Landscape* was cleaned in the early nineties, with revelatory results. The varnish which covered the surface had darkened significantly, which severely muted the blue area and made many of the gray areas too hot in value, thus destroying the entire color and value balance of the painting. The result was that the forms interrelated in confusing or flat, uninteresting ways; the painting lacked life and overall pictorial coherence. The cleaning process removed the dark and unevenly toned old varnish, and in doing so restored the full intensity of the blue color and gave the grays their true range of warm and cool overtones. This rebalancing of Gris's color intentions reinstated the clarity of the various individual shapes; pictorial solidity and coherence were regained. For the first time in many years *Cubist Landscape* can be seen very close to the way in which it left the artist's studio.

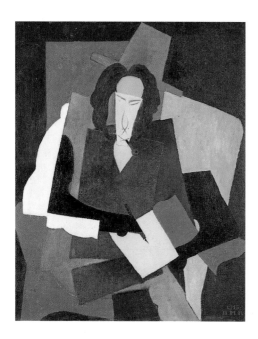

Diego María RIVERA
(Mexican, 1886-1957)
**Portrait of Ilya Ehrenburg,**
1915
*Retrato de Ilya Ehrenburg*
oil on canvas
Algur H. Meadows Collection
68.12

The style most often associated with Diego Rivera is one often called social realism. It is less known that the great Mexican muralist spent the years 1911 to 1920 in Paris, when Cubism represented the avante-garde. Rivera's Cubist works are rare, but they comprise the important first stage of his artistic maturity. The strong organizational demands made by the Cubist vision stayed with Rivera and were certainly a factor in his ability to organize the seething masses of his huge wall paintings.

Typical of Cubism, especially in its second, synthetic phase, was an intense focus on the picture surface itself, strengthened by the use of flatly colored, clearly defined shapes and varied paint textures. Wit was another frequent Cubist element, which Rivera has developed here through an extreme of paint texturing: the sitter's pipe and pen are so fully modeled that they resemble actual objects attached to the painting surface. The subject of Rivera's portrait, the Russian writer Ilya Ehrenburg (1891 - 1967), began as a poet in Paris, turning to prose in 1919; he spent his later career largely in Russia.

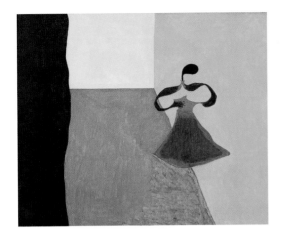

Joan MIRÓ (1893-1983)
**Queen Louise of Prussia**
*(Portrait de la Reine
Louise de Prusse)*, 1929
*La Reina Luisa de Prusia*
oil on canvas
Algur H. Meadows
Collection 67.16

*Queen Louise of Prussia*
comes from the close of the
decade during which Joan Miró transformed himself from a rising talent into a
great artist. During the final two years of this decade, Miró pursued parallel, if re-
lated, courses in his paintings. Some works were rather sparsely populated and
composed of relatively small-sized units separated by large areas of color, thinly
brushed and varied in brush stroke. Other works were dense with shape and event,
their organic forms with zoomorphic and anthropomorphic echoes developed as
curving, baroque shapes. Through these two modes an austere, more intellectual
Miró paralleled an opulent, more sensuous Miró.

Meadows Museum's *Queen Louise of Prussia,* one of several paintings which
Miró grouped under the description "Imaginary Portraits," belongs with the more
sparsely arranged, almost severe works. Another of the Imaginary Portraits which
was in the March 1930 showing of these works at Galerie Pierre in Paris, *Portrait of
Mistress Mills in 1750* (Museum of Modern Art, New York), represents the artist's
baroque side running parallel within this very circumscribed context.

Inspiration for works of art is often unexpected. None is more peculiar than
that for this work from Miró's series of imaginary portraits. The artist had torn
from a newspaper or magazine an hour-glass-shaped segment bearing advertise-
ments for a Junkers diesel engine and a shirt collar. On this torn sheet the artist did
a faint pencil sketch and wrote the words "very concentrated / pure spirit / no
painting." Explaining these lines later, Miró said, "I painted; but I didn't use the
nuances, the recipes of painting."

Through the alchemy of the creative process, Miró transformed a few lines
based on the diesel motor into a simplified female image. We know this because a
sequence of at least twelve sketches survives. After further adjustment of this im-
age, Miró began to rough in a setting, finally arriving at a sketch of his composi-
tion. During the late twenties, this careful preparation for the finished painting
through a series of sketches was Miró's standard way of working. Also following the
working methods of the grand tradition of European painting, the artist penciled
a grid over his final drawing to enable exact enlargement onto the canvas. If one
looks closely, one can see this pencil grid through the thin, translucent skin of paint
with which Miró realized this imaginary portrait.

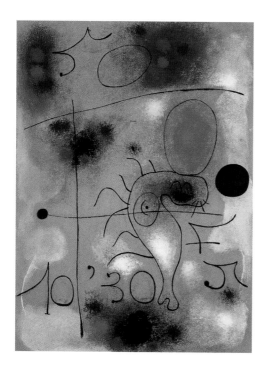

Joan MIRÓ (1893-1983)
**The Circus** *(Le Cirque),*
1937
*El circo*
tempera and oil on Celotex
Algur H. Meadows
Collection 67.15

Ebullient—"overflowing with excitement, enthusiasm, or exuberance"—is a word that perfectly evokes works such as this one by Joan Miró. They seem to rise off the material plane on which the forming lines and colors are laid and shimmer above the surface. This agile lightness of image and color is a wholly apt embodiment for the gaiety, evanescence, and activity which the word "circus" calls forth.

Energy bursts out here in the wiry line that is so much a part of Miró's touch. This line tautly energizes the principal image of seal and ball, and the soft-edged color splotches float like changing spotlights to complete the showlike evocation. A joyful mood, a bittersweet undercurrent of nostalgia: both are defined here more symbolically and suggestively than explicitly. Saying enough to lead the viewer, but not so much as to exhaust with overstatement, is a means Miró used to great effect in many works.

Antoni TÀPIES
(b. 1923)
**Great Black Relief**
*(Grand Noir),* 1973
*Gran Relieve Negro*
mixed media
Museum Purchase,
Meadows Museum
Acquisition Fund
88.01

This painting is an example of what is most accurately called non-objective art, in which the artist seeks to evoke mood and feeling and to instill meaning through the physical and formal means of painting: size, texture, shapes, layout, rhythm, color. Tàpies did not want to rely on recognizable images to relay his message, for these are always laden with conventional overtones, always carry preconceptions, and regularly imply a specific—therefore limited—narrative or story.

Tàpies hoped for something more universal, less place and time bound. Thus he used means intended to produce reactions from the unconscious areas of the viewer's being. The large size is aggressive, notice-demanding. The color range of gray, black, and white purposely avoids easy sensuous attraction and sets a somber, serious mood. Yet the inclusion of marble dust in the pigment, which gives the surface a virtually independent life of small sparkles and glitters and at the same time a velvety look, reintroduces sensuous, physical attractiveness. This is just one of a series of built-in contradictions intended to produce a consciousness-expanding shift of mood or perception in the viewer. The surface textures provide another such opposition: large expanses of the surface are broken by eruptions of bulging masses and, even more disturbingly, by wound-like gashes, while the surface pattern created by the textured rulings and the drawn white lines provides a lucid overlay to the turbulence of the bulging central swag of the wounds. The effect is ordering, calming, evocative of classical geometric shapes which seek to impose mathematical order on the chaos of undescribed space.

As a creative artist and a man of profound insights in the grimly repressive atmosphere of Franco-ruled Spain, Tàpies sought methods of indirect content to convey his message of the turbulent spiritual barrenness that the dictatorship produced. *Grand Noir* is a particularly heroic, unrelenting expression of one man's struggle with the darkness of that spirit-stifling, intellect-inhibiting era.

Xavier CORBERÓ (b. 1935)
**Cosmogonic Column, Grown-up Column, Morphological Column, and Seated Column,** 1980
*Columna cosmogónica, columna adulta, columna morfológica, y columna sentada*
white Carrara marble and pink Portuguese marble
Museum Purchase, Meadows Museum Acquisition Fund  83.02.01, 83.02.02, 83.02.03, and 83.02.04

Among the multitude of creative approaches artists of the later twentieth century have used, a frequent one is the evocation of past artistic traditions.  In Xavier Corberó's group of column  sculptures the ancient Mediterranean world is recalled.  These columns in their shining marble and essential shapes call forth for the viewer the Classical and above all the Roman.  Barcelona, where Corberó lives, is a city built on Roman ruins, where one encounters in unexpected places groups of columns which are all that remain of once-complete Roman buildings.

From this suggestion, the viewer can see these sculptures in more than one way.  They are pure, abstract shapes, and as such one focuses on their interaction with surrounding space, their subtle variations of individual contour and height as these interrelate, and the appealing tactile quality of their surfaces.  But they also activate the associative memory, bringing forth the life of a city layered through time and space.

Meadows Collection Checklists

\* Asterisks in the following checklists indicate works illustrated and discussed in this *Handbook*.

Anonymous, **Head of Saint Peter** [fragment] *(Cabeza de San Pedro)*, 1630-90. Oil on canvas, 11 1/4 x 8 1/4 inches. Algur H. Meadows Collection, 66.02.

\* Anonymous, **Portrait of Sir Arthur Hopton** *(Retrato de Sir Arthur Hopton)*, dated 1641. Oil on canvas, 73 3/4 x 46 inches. Algur H. Meadows Collection, 74.02.

Anonymous, **Portrait of Sir Samuel Ford Whittingham** *(Retrato de Sir Samuel Ford Whittingham)*, ca. 1815. Oil on canvas, 49 1/2 x 41 1/8 inches. Algur H. Meadows Collection, 75.03.

Anonymous, **Portrait of an Unknown Man** *(Retrato de un hombre desconocido)*, 1805-20. Oil on canvas, 19 7/8 x 15 1/8 inches. Gift of the Estate of John N. Estabrook, 88.07.

Anonymous, **Saint Francis of Assisi Receiving the Stigmata** *(San Francisco de Asís estigmatizado)*, 1670-1750. Oil on canvas, 34 1/4 x 28 3/4. Algur H. Meadows Collection, 66.30.

Anonymous, **Still Life with a Basket of Fruit** *(Bodegón con cesta de frutas)*, 1630-90. Oil on canvas, 14 1/4 x 19 inches. Algur H. Meadows Collection, 65.08.

Anonymous, **Vision of Saint Anthony of Padua** *(Visión de San Antonio de Padua)*, 1650-1700. Oil on canvas, 15 5/8 x 12 7/8 inches. Algur H. Meadows Collection, 65.06.

\* Anonymous Castilian, **Portrait of an Ecclesiastic** *(Retrato de un eclesiástico)*, 1620-30. Oil on canvas, 17 1/2 x 13 1/2 inches. Algur H. Meadows Collection, 71.03.

Anonymous Flemish, **The Immaculate Conception with a Wreath of Flowers** *(La Inmaculada Concepción con una guirnalda de flores)*, seventeenth century. Oil on canvas, 47 5/8 x 33 1/4 inches. Algur H. Meadows Collection, 66.03.

\* Anonymous Sevillian, **Still Life with Ram's Head** *(Bodegón con una cabeza de carnero)*, 1630-90. Oil on canvas, 21 1/2 x 30 1/2 inches. Algur H. Meadows Collection, 77.01.

Leonardo Alenza, **Card Players** *(Jugadores de cartas)*, signed, 1825-45. Oil on copper, 3 3/8 x 7 inches. Algur H. Meadows Collection, 65.09.

Leonardo Alenza, **A Spanking** *(Una azotaina)*, 1825-45. Oil on canvas, 8 1/4 x 6 7/8 inches. Algur H. Meadows Collection, 65.10.

Cristofano Allori, **Saint Catherine of Siena** *(Santa Catalina de Siena)*, 1612-1618. Oil on canvas, 42 3/8 x 35 1/4 inches. Algur H. Meadows Collection, 65.07.

\* Juan de Arellano, **Still Life with Flowers, Peaches, and Red Plums** *(Florero con melocotones y ciruelas rojas)*, signed, 1650-76. Oil on canvas, 33 x 41 3/8 inches. Museum Purchase, Meadows Acquisition Fund, 81.01.

\* Juan de Arellano, **Still Life with Flowers, Pears, and Other Fruits** *(Florero con peras y otras frutas)*, signed, 1650-76. Oil on canvas, 33 x 41 3/8 inches. Museum Purchase, Meadows Acquisition Fund, 81.02.

Mariano Barbasán y Lagueruela, **Autumn Landscape** *(Paisaje en otoño)*, signed, dated 1918. Oil on canvas, 11 x 15 7/8 inches. Algur H. Meadows Collection, 66.06.

\* Francisco Bayeu y Subías, **The Vision of Saint Francis in La Porciuncula** *(Visión de San Francisco en La Porciúncula)*, ca. 1781. Oil on canvas, 29 1/8 x 14 5/8 inches. Algur H. Meadows Collection, 75.05.

\* Martín Bernat, **Saint Blaise** *(San Blas)*, ca. 1480. Oil and gilding on panel, 53 1/4 x 38 1/8 inches. Museum Purchase, Meadows Foundation Funds, 97.01.

\* Juan de Borgoña, **The Investiture of Saint Ildefonsus** *(Imposición de la casulla a San Ildefonso)*, 1508-14. Tempera and oil on wood panel, 98 1/4 x 81 3/4 inches. Algur H. Meadows Collection, 69.03.

\* Juan Martín Cabezalero, **Saint Jerome** *(San Jerónimo)*, signed and dated 1666. Oil on canvas, 49 x 40 1/4 inches. Museum Purchase, Meadows Museum Acquisition Fund, 86.01.

Humberto Calzada, **Still life with Stained Glass** *(Naturaleza muerta con vitral)*, signed, painted 1987. Acrylic on canvas, 60 x 80 inches. Gift of Ricardo Pau-Llosa, 89.04.

\* Pedro de Camprobín Passano, **Still Life with Game Fowl** *(Bodegón con aves de caza)*, signed and dated 1653. Oil on canvas, 27 3/4 x 31 inches. Algur H. Meadows Collection, 72.03.

* Juan Carreño de Miranda, **The Martyrdom of Saint Bartholomew** *(El martirio de San Bartolomé),* signed and dated 1666. Oil on canvas, 73 1/2 x 98 3/4 inches. Algur H. Meadows Collection, 68.01.

* Juan Carreño de Miranda, **Portrait of the Dwarf Michol** *(Retrato del enano Michol),* 1670-82. Oil on canvas, 48 5/8 x 40 7/8 inches. Museum Purchase, Meadows Foundation Funds, 85.01.

* Antonio Casanova y Estorach, **Favorites of the Court** *(Les favoris de la cour) (Los favoritos de la corte),* signed and dated 1877. Oil on canvas, 34 3/4 x 51 1/2 inches. Algur H. Meadows Collection, 65.12.

Eduardo Chicharro y Aguera, **Fatima** *(Fátima),* signed, painted in 1927. Oil on canvas, 39 3/4 x 39 1/2 inches. Algur H. Meadows Collection, 66.07.

Antoni Clavé, **Untitled** *(Sin título),* signed, painted in 1954. Oil on board, 19 3/4 x 25 3/4 inches. Gift of Stanley Marcus, 93.01.

* Claudio Coello, **Saint Catherine of Alexandria Dominating the Emperor Maxentius** *(Santa Catalina de Alejandría dominando al Emperador Majencio),* 1664-65. Oil on canvas, 86 x 61 inches. Algur H. Meadows Collection, 76.01.

Francisco Domingo y Marqués, **The Red Ribbon** *(La cinta roja),* 1870-1900. Oil on canvas, 23 3/4 x 21 3/8 inches. Algur H. Meadows Collection, 69.19.

Francisco Domingo y Marqués, **Kitten on a Pillow** *(Gatito sobre un cojín),* signed and dated 1898. Oil on canvas, 21 5/8 x 18 inches. Algur H. Meadows Collection, 65.13.

* Joaquín Domínguez Bécquer, **Ladies and Gentlemen Visiting a Patio of the Alcázar of Seville** *(Visita a un patio del Alcázar de Sevilla),* signed and dated 1857. Oil on canvas, 20 1/8 x 24 inches. Algur H. Meadows Collection, 65.15.

Valeriano Domínguez Bécquer Bastida, **The Morning Coiffure** *(El peinado matutino),* signed and dated 1859. Oil on canvas, 14 5/8 x 11 1/8 inches. Algur H. Meadows Collection, 65.11.

Raphael Durancamps, **Sunday at the Bullring** *(Capea),* signed, painted 1934-1945. Oil on canvas, 21 1/2 x 25 5/8 inches. Anonymous Gift, 91.12.

* Antonio María Esquivel, **Woman Removing Her Garter** *(Mujer al quitarse la liga),* signed and dated 1842. Oil on canvas, 52 1/2 x 42 5/8 inches. Algur H. Meadows Collection, 65.16.

Mariano Fortuny i Marsal, **Man and Girl** *(Hombre y señorita),* 1860-70. Oil on canvas, 8 3/4 x 10 1/2 inches. Algur H. Meadows Collection, 66.09.

* Mariano Fortuny i Marsal, **Beach at Portici** *(Playa en Portici),* signed, 1873-74. Oil on canvas, 29 1/8 x 12 3/4 inches. Algur H. Meadows Collection, 71.05.

* Francisco or Fernando Gallego, **Acacius and the 10,000 Martyrs on Mount Ararat** *(Acacio y los 10,000 mártires del Monte Ararat),* ca. 1490. Tempera and oil on wood panel, mounted on composition board, 60 3/4 x 44 x 1 1/4 inches. Algur H. Meadows Collection, 68.02.

* Antonio González Ruiz, **Portrait of the Cardinal Infante Don Luis Antonio de Borbón** *(Retrato del Cardenal Infante Don Luis Antonio de Borbón),* signed and dated 1742. Oil on canvas, 82 3/4 x 58 inches. Gift of Colonel C. Michael Paul and The Paul Foundation, New York, 70.10.

* Antonio González Velázquez, **Allegory of the Spanish Monarchy** *(Alegoría de la monarquía española),* 1753-64. Oil on canvas, 46 5/8 x 74 3/4 inches. Museum Acquisition, by exchange, 79.02.

* Francisco José de Goya y Lucientes, **Portrait of Francisco Sabatini** *(Retrato de Francisco Sabatini),* 1775-79. Oil on canvas, 32 5/8 x 24 1/2 inches. Algur H. Meadows Collection, 67.03.

* Francisco José de Goya y Lucientes, **Yard with Madmen** *(Corral de locos),* 1794. Oil on tin-plated iron: 16 7/8 x 12 3/8 inches [irregular]. Algur H. Meadows Collection, 67.01.

* Francisco José de Goya y Lucientes, **Unfinished Portrait of a Lady** *(Retrato inacabado de una dama),* 1804-08. Oil on canvas, 29 5/8 x 20 7/8 inches. Algur H. Meadows Collection, 67.04.

* Francisco José de Goya y Lucientes, **Students from the Pestalozzian Academy** [fragment] *(Estudiantes de la Academia Pestalozzi [fragmento]),* 1806-07. Oil on canvas, 21 3/4 x 38 1/4 inches. Algur H. Meadows Collection, 67.24.

* Francisco José de Goya y Lucientes, **Still Life with Woodcocks** *(Bodegón de chochaperdices),* 1808-12. Oil on canvas, 17 7/8 x 24 3/4 inches. Algur H. Meadows Collection, 71.01.

Follower of Goya, **Bulls Being Led through an Arch** *(Toros conducidos a través de un arco).* Oil on wood panel, 12 1/2 x 18 3/8 inches. Algur H. Meadows Collection, 65.17.

Follower of Goya, **Picador** *(Picador).* Oil on wood panel, 12 1/4 x 16 1/4 inches. Algur H. Meadows Collection, 65.18.

Follower of Goya, **La Capea** *(La capea).* Oil on canvas, 18 1/8 x 23 1/8 inches. Algur H. Meadows Collection, 65.19.

* El Greco (Domenikos Theotokopoulos), **Saint Francis Kneeling in Meditation** *(San Francisco arrodillando en meditación),* 1605-1610. Oil on canvas, 29 7/8 x 25 inches. Museum Purchase, Meadows Museum Acquisition Fund with private donations and University funds, 99.01.

Copy after El Greco, **Christ Carrying the Cross** *(Cristo con la cruz acuestas).* Oil on canvas, 32 1/8 x 24 1/8 inches. Algur H. Meadows Collection, 65.22.

Forgery of El Greco, **The Adoration of the Shepherds** *(La Adoración de los Pastores).* Oil on canvas, 24 7/8 x 17 7/8 inches. Algur H. Meadows Collection, 65.20.

Forgery of El Greco, **The Annunciation** *(La Anunciación).* Oil on canvas, 42 5/8 x 33 inches. Algur H. Meadows Collection, 65.21.

* Juan Gris, **Cubist Landscape** *(Paisaje cubista),* signed, painted in 1917. Oil on wood panel, 45 3/4 x 28 1/2 inches [irregular]. Algur H. Meadows Collection, 67.25.

Eugenio Hermoso, **Boy at a Table** *(Niño sentado a la mesa),* signed and dated 1903. Oil on canvas, 37 5/8 x 25 1/2 inches. Algur H. Meadows Collection, 66.10.

Eugenio Hermoso, **Manolita** *(Manolita),* signed and dated 1908. Oil on canvas, 51 1/8 x 27 5/8 inches. Algur H. Meadows Collection, 66.11.

Juan de Herrera, **Virgin and Child with the Young Saint John the Baptist** *(La Virgen y el niño Jesús con San Juan Bautista niño),* signed and dated 1641. Oil on canvas, 25 1/4 x 21 1/4 inches. Algur H. Meadows Collection, 69.23.

Ignacio de Iriarte, **Tobias and the Angel** *(Tobías y el ángel),* 1650-80. Oil on canvas, 30 5/8 x 40 3/8 inches. Gift of Mrs. Elizabeth M. Drey, New York, 77.06.

* José Jiménez Aranda, **The Smokers** *(Los fumadores),* signed, painted in 1890. Oil on wood panel, 14 3/8 x 18 1/8 inches. Algur H. Meadows Collection, 65.23.

* Luis Jiménez Aranda, **Lady at the Paris Exposition** *(Dama en la Exposición de París),* signed and dated 1889. Oil on canvas, 47 1/2 x 27 7/8 inches. Algur H. Meadows Collection, 69.24.

Juan de Juanes, **Christ in the Arms of Two Angels** *(Cristo en los brazos de dos ángeles),* 1550-75. Oil on wood panel, 60 1/16 x 40 9/16 inches. On loan from the Dallas Museum of Art, DMA 1962.1.

* Alonso López de Herrera, *A double painting on copper, obverse and reverse:* (a) **Saint Thomas Aquinas** *(Santo Tomás Aquino)*; (b) **Saint Francis** *(San Francisco);* signed and dated 1639. Oil on copper, 14 1/2 x 11 1/2 inches [irregular]. Museum Purchase, Meadows Museum Acquisition Fund, 88.08 a and b.

* Vicente López y Portaña, **Saint Vincent Martyr Before Dacius** *(San Vicente Mártir delante Daciano),* ca. 1796. Oil on canvas, 19 1/2 x 12 1/2. Museum Purchase, Meadows Museum Acquisition Fund, 94.02.

* Vicente López y Portaña, **Portrait of the Baron Mathieu de Faviers** *(Retrato del Barón Mathieu de Faviers),* signed and dated 1812. Oil on canvas, 27 1/2 x 23 1/8 inches. Algur H. Meadows Collection, 65.24.

* Vicente López y Portaña, **Portrait of the Marqués de Nevares** *(Retrato del Marqués de Nevares),* signed and dated 1840. Oil on canvas, 41 1/8 x 33 inches. Algur H. Meadows Collection, 65.25.

* Eugenio Lucas Velázquez, **Cattle Drive** *(Manada de reses),* signed and dated 1852. Oil on canvas, 29 5/8 x 44 3/8 inches. Algur H. Meadows Collection, 65.26.

Eugenio Lucas Velázquez, **Religious Procession** *(Procesión religiosa),* signed and dated 1855. Oil on wood panel, 5 7/8 x 4 5/8 inches. Algur H. Meadows Collection, 65.27.

* Raimundo de Madrazo y Garreta, **Self-Portrait** *(Autorretrato),* signed and dated 1901. Oil on canvas, 32 1/8 x 24 5/8 inches. Algur H. Meadows Collection, 73.01.

Copy after Federico Madrazo y Kuntz, **Portrait of the Duchess of Medinaceli** *(Retrato de la Duquesa de Medinaceli),* after 1864. Oil on canvas, 56 3/4 x 34 3/4 inches. Algur H. Meadows Collection, 76.03.

Copy after Federico Madrazo y Kuntz, **Portrait of the Duke of Medinaceli** *(Retrato del Duque de Medinaceli),* after 1864. Oil on canvas, 56 3/8 x 34 1/2 inches. Algur H. Meadows Collection, 76.04.

* Mariano Salvador de Maella, **Spain and the Four Parts of the World** *(España acompañada de las cuatro partes del mundo),* circa 1792. Oil on canvas, 23 1/8 x 15 inches. Museum Purchase, Meadows Foundation Funds (given in honor of Dr. William B. Jordan, Museum Director 1967-1981), 81.11.

* Juan Bautista Maino, **Adoration of the Shepherds** *(Adoración de los pastores),* 1615-20. Oil on canvas, 63 x 47 inches. Museum Purchase, Meadows Museum Acquisition Fund, 94.01.

* Joaquín Mir Trinxet, **Catalan Landscape** *(Paisaje catalán)*, signed, painted before 1928. Oil on canvas, 28 3/4 x 41 1/4 inches [irregular]. Algur H. Meadows Collection, 65.29.

* Joan Miró, **Queen Louise of Prussia** *(Portrait de la Reine Louise de Prusse) (Retrato de la reina Luisa de Prusia)*, painted in 1929. Oil on canvas, 32 1/2 x 39 3/4 inches. Algur H. Meadows Collection, 67.16.

* Joan Miró, **The Circus** *(Le Cirque) (El circo)*, signed, painted in 1937. Tempera and oil on Celotex, 47 1/2 x 35 3/4 inches [irregular]. Algur H. Meadows Collection, 67.15.

* Anthonis Mor, **Portrait of Alessandro Farnese** *(Retrato de Alessandro Farnese)*, dated 1561. Oil on canvas, 71 3/8 x 38 7/8 inches. Algur H. Meadows Collection, 71.04.

* Luis de Morales, **Pietà** *(Piedad)*, ca. 1560. Oil on panel, 16 1/4 x 11 3/4 inches. Museum Purchase, Meadows Foundation Funds, 95.01.

Gabriel Morcillo Raya, **Girl with a Vase** *(Señorita con florero)*, signed and dated 1921. Oil on canvas, 41 1/2 x 33 1/2 inches. Algur H. Meadows Collection, 67.17.

* Bartolomé Esteban Murillo, **The Immaculate Conception** *(La Inmaculada Concepción)*, 1655-60. Oil on canvas, 84 x 55 3/8 inches. Algur H. Meadows Collection, 68.24.

* Bartolomé Esteban Murillo, **Jacob Laying Peeled Rods Before the Flocks of Laban** *(Jacob pone las varas al ganado de Labán)*, ca. 1665. Oil on canvas, 87 3/4 x 142 inches. Algur H. Meadows Collection, 67.27.

* Bartolomé Esteban Murillo, **Saint Justa** *(Santa Justa)*, ca. 1665. Oil on canvas, 36 5/8 x 26 1/8 inches. Algur H. Meadows Collection, 72.04.

* Bartolomé Esteban Murillo, **Saint Rufina** *(Santa Rufina)*, ca. 1665. Oil on canvas, 36 3/4 x 26 1/8 inches. Algur H. Meadows Collection, 72.05.

* Bartolomé Esteban Murillo, **Christ on the Cross with the Virgin, Mary Magdalen, and Saint John** *(Cristo Crucificado con la Vírgen, María Magdalena, y San Juan)*, ca. 1670. Oil on copper, 26 3/8 x 18 7/8 inches. Algur H. Meadows Collection, 67.11.

* Antonio de Palomino y Velasco, **The Immaculate Conception** *(La Inmaculada Concepción)*, 1695-1720. Oil on canvas, 74 x 49 1/2 inches. Museum Purchase, Meadows Foundation Funds, 80.01.

* Juan Pantoja de la Cruz, **Portrait of the Archduke Albert** *(Retrato del Archiduque Alberto),* ca. 1600. Oil on canvas, 23 1/2 x 20 7/8 inches. Algur H. Meadows Collection, 65.33.

* Juan Pantoja de la Cruz, **Portrait of the Archduchess Infanta Isabella Clara Eugenia** *(Retrato de la Archiduquesa Infanta Isabella Clara Eugenia),* ca. 1600. Oil on canvas, 23 1/2 x 20 7/8 inches. Algur H. Meadows Collection, 65.34.

* Antonio de Pereda, **Saint Joseph and the Christ Child** *(San José y el Niño Jesús),* signed and dated 1655. Oil on canvas, 82 3/4 x 41 1/2 inches. Algur H. Meadows Collection, 77.05.

* Genaro Pérez Villaamil, **Romantic Landscape** *(Paisaje romántico),* signed and dated 1843. Oil on canvas, 16 5/8 x 22 5/8 inches. Algur H. Meadows Collection, 65.31.

* Pablo Ruiz Picasso, **Still Life in a Landscape** *(Naturaleza muerta en un paisaje),* signed, painted in 1915. Oil on canvas, 24 1/2 x 29 3/4 inches. Algur H. Meadows Collection, 69.26.

Francisco Pradilla y Ortiz, **Head of a Boy** *(Cabeza de un niño),* signed and dated 1887. Oil on canvas, mounted on masonite, 22 1/8 x 17 5/8 inches. Algur H. Meadows Collection, 66.12.

Albert Rafols-Casamada, **Untitled** *(Sin título),* 1983. Oil on canvas, 59 x 59 inches. Gift of Robert N. McNea in memory of Franklin E. Moss, 91.01.

* Darío de Regoyos y Valdés, **Thaw in the Pyrenees** *(Deshielo en los Pirineos),* signed, ca. 1886. Oil on canvas, 47 1/2 x 59 3/8 inches. Gift of the Meadows Foundation, Inc., 66.13.

Antonio María Reyna y Manescau, **Venice** *(Venezia) (Venecia),* signed, early twentieth century. Oil on canvas, 13 5/8 x 29 1/2 inches. Gift of Dr. and Mrs. Ben Harrison, 88.02.

* Jusepe de Ribera, **Portrait of a Knight of Santiago** *(Retrato de un Caballero de Santiago),* 1630-38. Oil on canvas, 57 1/2 x 42 inches. Algur H. Meadows Collection, 77.02.

* Jusepe de Ribera and Assistants, **Saint Paul the Hermit** *(San Pablo Ermitaño),* 1635-50. Oil on canvas, 55 1/4 x 78 5/8 inches. Algur H. Meadows Collection, 75.01.

Follower of Jusepe de Ribera, **Wise Man with a Looking Glass (The Sense of Sight)** *(Sábio con espejo [El sentido de la vista]),* seventeenth century. Oil on canvas, 40 3/8 x 30 7/8 inches. Algur H. Meadows Collection, 65.35.

* Diego María Rivera, **Portrait of Ilya Ehrenburg** *(Retrato de Ilya Ehrenburg),* signed and dated 1915. Oil on canvas, 43 3/8 x 35 1/4 inches. Algur H. Meadows Collection, 68.12.

Manuel Rodríguez de Guzmán, **La Romería del Rocío (A Folk Festival)** *(La Romería del Rocío),* signed and dated 1856. Oil on canvas, 26 x 37 inches. Algur H. Meadows Collection, 65.36.

Eduardo Rosales, **Portrait of a Girl** *(Retrato de una niña),* 1855-73. Oil on canvas, 13 3/4 x 11 1/4 inches. Algur H. Meadows Collection, 66.15.

* Emilio Sánchez Perrier, **River Landscape** *(Paisaje fluvial),* signed, 1880-1907. Oil on wood panel, 15 1/8 x 21 3/4 inches. Algur H. Meadows Collection, 71.02.

José María Sert y Badia, **Peace** *(La paz),* ca. 1936. Oil on gold leaf paper-board, 32 1/2 x 25 1/2 inches. Algur H. Meadows Collection, 67.19.

José María Sert y Badia, **Progress** *(El progreso industrial),* ca. 1936. Oil on gold leaf on paper-board, 32 1/2 x 25 1/2 inches. Algur H. Meadows Collection, 67.20.

* Juan de Sevilla, **The Immaculate Conception** *(La Inmaculada Concepción),* 1660-75. Oil on canvas, 95 1/2 x 64 1/4 inches. Algur H. Meadows Collection, 67.13.

* Joaquín Sorolla y Bastida, **View of Las Pedrizas from El Pardo** *(Vista de Las Pedrizas desde El Pardo),* signed and dated 1907. Oil on canvas, 24 1/4 x 36 1/8 inches. Algur H. Meadows Collection, 65.37.

* Antoni Tàpies, **Great Black Relief** (***Grand Noir***) *(Gran relieve negro),* painted in 1973. Mixed media and canvas on plywood panel, 98 5/8 x 108 3/8 inches [irregular]. Museum Purchase, Meadows Museum Acquisition Fund, 88.01.

Augustín Úbeda, **Untitled** *(Sin título).* Oil on canvas, 21 5/8 x 25 7/8. Transfer from University Art Collection, 95.03.

* Juan de Valdés Leal, **Joachim and the Angel** *(Joaquín y el ángel),* 1655-60. Oil on canvas, 57 3/4 x 82 3/8 inches [irregular]. Museum Acquisition, by exchange, 86.04.

Juan Van der Hamen y León, **Landscape with a Garland of Flowers** *(Paisaje con una guirnalda de flores),* ca. 1630. Oil on canvas, 41 x 33 1/2 inches. Algur H. Meadows Collection, 67.26.

* Diego Rodríguez de Silva y Velázquez, **Portrait of King Philip IV** *(Retrato del Rey Felipe IV)*, 1623-24. Oil on canvas, 24 3/8 x 19 1/4 inches. Algur H. Meadows Collection, 67.23.

* Diego Rodríguez de Silva y Velázquez, **Female Figure (Sibyl with Tabula Rasa)** *(Mujer, Sibila con tábula rasa)*, ca. 1648. Oil on canvas, 25 1/2 x 23 inches. Algur H. Meadows Collection, 74.01.

* Diego Rodríguez de Silva y Velázquez, **Portrait of Queen Mariana** *(Retrato de la Reina Mariana)*, ca. 1656. Oil on canvas, 18 3/8 x 17 1/8 inches. Algur H. Meadows Collection, 78.01.

Copy after Velázquez, **Portrait of Luis de Góngora** *(Retrato de Luis de Góngora)*, seventeenth century, after an original of 1622. Oil on canvas, 23 1/8 x 17 1/4 inches. Algur H. Meadows Collection, 66.01.

* Fernando Yáñez de la Almedina, **Saint Sebastian** *(San Sebastián)*, ca. 1506. Oil on wood panel, 69 3/8 x 32 7/8 inches. Algur H. Meadows Collection, 76.02.

Miguel Zapata, **Untitled [Bishop from Astorga Cathedral]** *(Sin título [Obispo de la catedral de Astorga])*, signed and dated 1985. Mixed media on painted relief, 48 5/8 x 36 1/2 x 3 1/2 inches. Meadows Foundation Funds, 86.06.

Fernando Zobel, **Untitled** *(Sin título)*, signed, painted in 1971. Oil on canvas, 31 1/2 x 31 1/2 inches. Gift of Sally Steinberg, 92.03.

Ignacio Zuloaga, **Spanish Landscape** *(Paisaje español)*, signed, painted 1915-20. Oil on paper, 46 1/4 x 75 5/8 inches. Algur H. Meadows Collection, 65.38.

* Ignacio Zuloaga, **The Bullfighter "El Segovianito"** *(El Toreador "El Segovianito")*, signed, 1912. Oil on canvas, 78 3/4 x 42 3/4 inches. Algur H. Meadows Collection, 71.08.

* Francisco de Zurbarán, **The Mystic Marriage of Saint Catherine of Siena** *(Los desposorios místicos de Santa Catalina de Siena)*, 1640-60. Oil on canvas, 46 3/8 x 41 1/8 inches. Algur H. Meadows Collection, 67.14.

Anonymous, **Figure from a Religious Scene** *(Personaje de una escena religiosa),* eighteenth century. Polychromed wood, 49 x 30 1/2 x 10 inches. Anonymous Gift, 95.02.

* Anonymous, **Hispano-Moresque Charger** *(Plato grande hispano-moresco),* ca. 1500. Lusterware ceramic, 19 inches in diameter. Museum Purchase, Meadows Foundation Fund, 89.08.

* Anonymous, **Saint Ignatius Loyola** *(San Ignacio de Loyola),* 1609-22. Polychromed and gilded wood, 26 5/8 x 19 1/4 x 13 7/8 inches. Meadows Museum Acquisition Fund, 87.15.

* Anonymous Catalonian, **Eucharistic Cabinet** *(Armario eucarístico),* 1375-1400. Tempera, gilding, and glazed silver leaf on poplar wood, 92 1/4 x 42 1/4 x 21 1/4 inches. Museum Purchase, Meadows Foundation Funds, 91.07.

* Anonymous Hispano-Islamic Sculptor, **Capital from Madinat al-Zahra'** *(Capitel de Madinat al-Zahra'),* ca. 965. Carved marble, 10 3/4 x 10 1/2 x 10 1/2 inches. Museum Purchase, Meadows Foundation Funds, 96.01.

* Anonymous Sevillian, **Saint Anthony of Padua Holding the Christ Child** *(San Antonio de Padua con el Niño Jesus),* ca. 1700. Polychromed wood and ivory, 28 x 14 x 12 1/4 inches. Museum Purchase, Meadows Museum Acquisition Fund, 89.07.

Pascoali Caetano Oldovini, **Organ** *(Órgano),* circa 1762. Chestnut wood case, boxwood and ebony keys, tin and organ metal, 102 1/4 x 49 1/2 x 28 1/4 inches. Gift of the Meadows Foundation, 83.05.

* Xavier Corberó, **Cosmogonic Column, Grown-up Column, Morphological Column, Seated Column** *(Columna cosmogónica, columna adulta, columna morfológica, columna sentada),* 1980. All white Carrara marble; **Cosmogonic Column** with additions in pink Portuguese marble. **Cosmogonic:** 92 x 14 x 14 1/2 inches; **Grown-up:** 43 1/2 x 13 x 13 inches; **Morphological:** 31 1/2 x 14 1/2 x 14 1/2 inches; **Seated:** 21 x 13 1/3 x 13 1/3 inches. Museum Purchase, Meadows Museum Acquisition Fund, 83.02.01, 83.02.02, 83.02.03, and 83.02.04.

* Circle of Juan de Juní, **Saint Ursula** *(Santa Úrsula),* second half of the sixteenth century. Polychromed and gilded wood, 24 x 18 x 10 inches; base: 3 1/2 x 20 1/2 x 11 1/2 inches. Museum Purchase, Meadows Museum Acquisition Fund, 92.01.

*   Follower of Pedro de Mena, **Saint Francis of Assisi** *(San Francisco de Asís)*, late seventeenth century. Polychromed wood, bone/ivory teeth, glass eyes, 29 1/4 x 9 1/8 x 8 3/4 inches; base: 1 3/4 x 11 1/8 x 8 3/4 inches. Museum Purchase, Meadows Museum Acquisition Fund, 90.05.

*   Juan Martínez Montañés, **Saint John the Baptist** *(San Juan Bautista)*, 1630-35. Polychromed wood, 48 x 27 x 24 1/2 inches. Museum Purchase, Meadows Museum Acquisition Fund, 79.01.

*   Alejo de Vahía, **Lamentation** *(Lamentación)*, 1490-1510. Polychromed and gilded wood, 41 x 37 x 10 1/2 inches. Museum Purchase, Meadows Museum Acquisition Fund, 89.02.